UNDERSTANDING
SHUTTER SPEED

UNDERSTANDING SHUTTER SPEED

CREATIVE ACTION AND LOW-LIGHT PHOTOGRAPHY BEYOND 1/125 SECOND

BRYAN PETERSON

AMPHOTO BOOKS

AN IMPRINT OF WATSON-GUPTILL PUBLICATIONS/NEW YORK

Page 1: 70–200mm lens at 105mm, ISO 100, 1/4 sec. at f/4.5

Pages 2–3: 17–55mm lens, tripod, ISO 100, 2 seconds at f/8

Page 5: 70–200mm lens at 200mm, tripod, ISO 100, 1/60 sec. at f/8

Pages 6–7: 70–200mm lens, ISO 100, 1/30 sec. at f/16

Pages 8–9: ISO 400, 1/800 sec. at f/11

Page 11: 70–200mm lens at 116mm, ISO 200, 1/2 sec. at f/22

Pages 12–13: 17–55mm lens at 55mm, ISO 100, 1/10 sec. at f/22

Pages 22–23: 12–24mm lens at 12mm, ISO 400, 1/750 sec. at f/6.3

Pages 60–61: Nikon D2X, 12–24mm lens, 4-stop ND filter, ISO 100, 2 seconds at f/16

Pages 118–119: 16 minutes at f/32, Kodachrome 64

Pages 144–145: 1/8 sec. at f/11

First published in 2008 by Amphoto Books
an imprint of Watson-Guptill Publications
the Crown Publishing Group,
a division of Random House, Inc., New York

www.crownpublishing.com
www.watsonguptill.com
www.amphotobooks.com

Editorial Director: Victoria Craven
Senior Development Editor: Alisa Palazzo
Art Director: Timothy Hsu
Designer: Bob Fillie, Graphiti Design, Inc.
Production Manager: Sal Destro
Cover design by Gabriele Wilson and Timothy Hsu

Copyright © 2008 Bryan Peterson

Library of Congress Cataloging-in-Publication Data
Peterson, Bryan F.
 Understanding shutter speed : creative action and low-light photography
beyond 1/125 second / Bryan Peterson.
 p. cm.
 Includes index.
 ISBN-13: 978-0-8174-6301-4 (pbk.)
 ISBN-10: 0-8174-6301-1 (pbk.)
1. Photography—Exposure. I. Title.

 TR591.P52 2008
 771—dc22

 2007030955

Typeset in DIN and Gotham

Printed in Thailand

 2 3 4 5 6 7 8 9 / 16 15 14 13 12 11 10 09 08

Acknowledgments
I can't express my gratitude enough
to Victoria Craven (editorial director at
Amphoto Books) and to Alisa Palazzo
and Bob Fillie (my ever-faithful and
talented editor and designer, respectively).
They all give so much of their time and
dedication to my books. Thank you,
thank you, thank you again!

To Harry and Mo

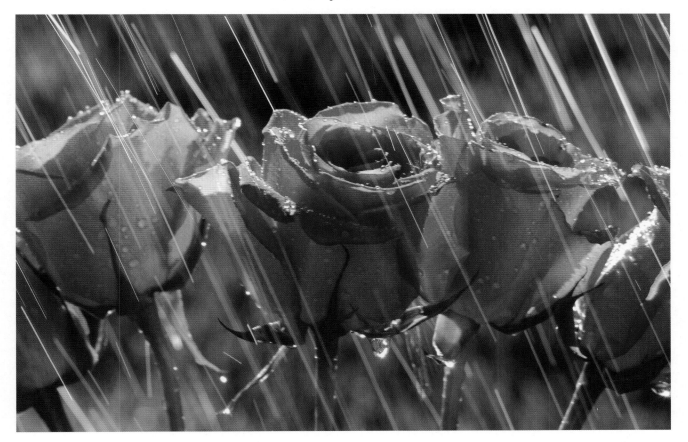

CONTENTS

INSERT COIN
TURN HANDLE TO RIGHT
AS FAR AS POSSIBLE
AFTER EACH COIN
POM Inc. Russellville, AL USA

INSERT COIN
TURN HANDLE TO RIGHT
AS FAR AS POSSIBLE
AFTER EACH COIN
POM Inc. Russellville, Ar, USA

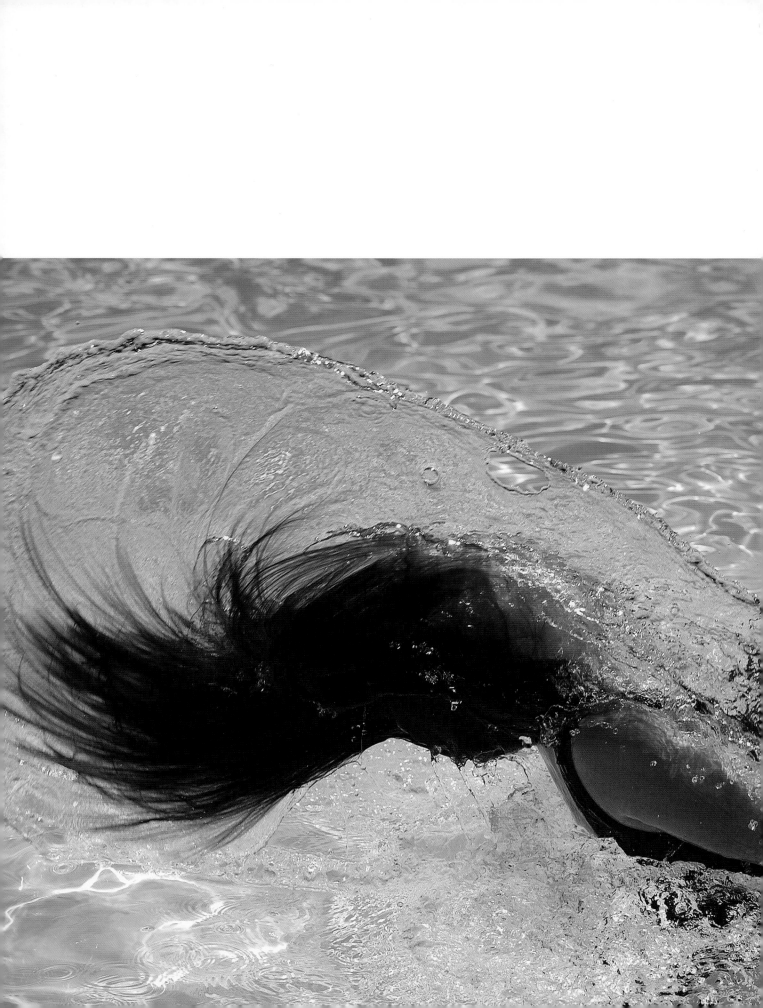

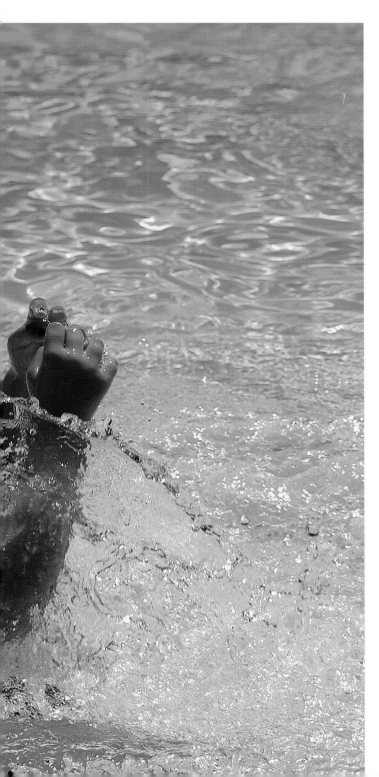

It was some years ago, back in 1977 I believe, when I came across this quotation from an unknown source about the topic of time: "Today, be aware of how you are spending your 1,440 beautiful moments and spend them wisely." It's amusing that this person was obviously so immersed in, and so consumed by, how he (or she) was spending each moment that he forgot to tell whomever he was speaking to his name.

Looking back at how I was spending my time in 1977, it's fair to say that time had less relevance to me than it does today. It could easily be argued that time has simply become more important today because I'm getting older, but I would have to disagree if only because I seem to have always valued my time and tried to make the best use of it. And to be clear, I'm not really speaking about, or addressing, the issue of "saving time" or "wasting time" but rather about the *joy* of recording time! The irony, of course, is that by recording time via the simple act of pushing a button on a still camera, one *can* experience the pleasure of time well spent!

I, for one, do believe that there are at least "1,440 beautiful moments" (aka each and every minute) in a day; yet I also believe that many of these 1,440 beautiful moments zip right past me, sight unseen, simply because I don't have *time* to notice or appreciate their fleeting beauty. It has only been in the last several years that I've found myself making a concerted effort to really become aware of these 1,440 beautiful moments, and although my journey is still in its early stages, it's a journey that offers up these moments every day.

Have you done the math? Those 1,440 minutes translate into no less than 1,440 sixty-second exposures! Do you have any idea how beautiful a moment can be when photographed over the course of sixty seconds? A city scene at dusk. A lighthouse atop a cliff just out of range of the assaulting surf.

Then there are the 86,400 seconds that make up those 1,440 beautiful moments. And here is one amazing fact that's guaranteed to make you realize just how

fleeting time can be: 1/1000 sec. is a perfect shutter speed to use when you wish to capture in exacting sharpness many of life's daily 1,440 beautiful moments. So, how many one-thousandths does it take to make a second? Well, 1,000, of course! That also means that it takes another 60,000 one-thousandths to make a minute and 360,000 one-thousandths to make an hour. And that can only mean that those 1,440 beautiful moments are composed of exactly 8,640,000 one-thousandths. Yikes! Every day, we, as photographers, are afforded the opportunity to freeze, in exacting sharpness, 8,640,000 action-filled images. And to think that you have often lamented that you can't find anything to shoot! I concur that some of life's "beautiful moments" are often too quick, too fleeting, to be seen by the human eye, but certainly, we can find other moments among the 8,640,000 daily opportunities to record an exciting image.

Most every moment—no matter how big or small— offers up a subject in a perpetual state of motion: jumping, slapping, hitting, running, walking, flying, diving, leaping, dancing, reaching, throwing, falling, sliding, pulling, pushing, slamming, blowing, splashing, beating, fluttering, bouncing, turning, exploding, spinning, breaking, smashing, splattering, or crashing. All of this motion translates into energy, and a well-executed photograph that conveys that motion is a photograph that is filled with both motion and *emotion*!

Whether it be in a book or magazine, all of us have seen and felt the energy of two soccer players, caught in midair, heading a soccer ball, rendered in an image in exacting sharpness! "Whoa, look at that!" we remark in a tone of utter amazement. And all of us have seen images that convey the angelic and cotton-candy-like effect of a waterfall shot at a slow shutter speed. "I find it so soothing to look at" is often the response. Unlike motionless photographs (the proverbial close-up of a flower, for example), well-executed motion-and-emotion-filled images are forever "on the move." And it is this movement and the energy that is conveyed that appeal to our very own psychological need to have movement under our feet. Without movement, we die, and perhaps that is also why photographers seem to enjoy a better-than-average level of mental health. We are pushed to record, to create, and no other images are as life-affirming as motion-filled images. These are the images that celebrate "life on the move" with the greatest of exclamations.

There are, of course, a number of ways to capture movement, and the methods you choose to convey that movement will, in large measure, be determined by the shutter speed you choose and the movement of the subject before you. The motion-and-emotion-filled images that result can be felt as soothing, calming, seething, shocking, surprising, or frightening. There are also ways to convey movement with subjects that don't ordinarily move (for example, a large boulder stuck in a hillside). In effect, with the right shutter speed, you get to play God and breathe life into "dead" subjects by the simple act of zooming your lens while shooting at a slow shutter speed.

Perhaps you're not sure which shutter speed to use. Perhaps you're not sure which lens to use. Perhaps you're not sure what your exposure should be. Perhaps you're not sure about your overall composition. Perhaps you're not sure where to take your meter reading from. Perhaps you're at that place where you aren't even aware that motion-filled images exist. All of the known techniques for capturing, conveying, and creating movement in a single still photograph are covered in this book in a simple, clear, and concise format, with examples taken dawn to dusk, into the dark of night, and with available light, flash, strobes, and other sources of light. And as has been the case with my other photography books, and where I feel it's most necessary, I've chosen to present before-and-after pairs of images that clearly show distinct differences in exposure, composition, lens choice, or lighting. Of course due to page limitations, I'm not able to show you *all* of my examples of "life on the move," but I do list many other subjects to which these same principles could easily be applied.

SHUTTER SPEED
FACTS & MYTHS

ONE PHOTO OP, SIX CORRECT EXPOSURES

Did you know that most picture-taking situations have at least six possible combinations of f-stops and shutter speeds that will *all* result in a correct exposure? They may not all be *creatively correct* photographic exposures, but they will all be correct. More often, only one or two of these f-stop/shutter speed combinations is the creatively correct motion-filled exposure.

Every correct exposure is nothing more than the quantitative value of an aperture and shutter speed working together within the confines of a predetermined ISO. For the sake of argument, let's say that you and I are both out shooting a city skyline at dusk using an ISO of 100 and an aperture opening of f/5.6. Let's also say that, whether we're shooting in manual or Aperture Priority mode, the light meter indicates a correct exposure at 1 second. What other combinations of aperture openings (f-stops) and shutter speeds can we use and still record a "correct" exposure? If I suggest we use an aperture of f/8, what would the shutter speed now be? Since we've cut the lens opening in half (from f/5.6 to f/8), we now need to double the shutter speed time to 2 seconds to record a correct exposure. On the other hand, if I suggest we use an aperture of f/4, what would the shutter speed now be? Since we've just doubled the size of the lens opening (f/5.6 to f/4), we now need to cut the shutter speed in half (to 1/2 sec.) to record the same *quantitative value exposure*.

Easy, yet hard, right? Here are the equations (which all yield the same quantitative exposure in this situation):

> f/4 for 1/2 sec. is the same as
> f/5.6 for 1 second, which is the same as
> f/8 for 2 seconds, which is the same as
> f/11 for 4 seconds, which is the same as
> f/16 for 8 seconds, which is the same as
> f/22 for 16 seconds

Add them up and what have you got? Six possible combinations of apertures and shutter speeds that will all result in exactly the same exposure. And by *same*, I mean the same in terms of *quantitative value only*! I can't stress enough the importance of being aware of this *quantitative value* principle. It doesn't matter if you're shooting with a film-based camera or a digital camera; you must learn to embrace a simple fact: Every picture-taking opportunity offers you no less than six possible aperture/shutter speed combinations. And why must you know this? Even though each combo has the "same" exposure, the motion captured by each may look radically different. Knowing that each motion-filled exposure opportunity offers up six possible combinations is a start, but knowing which one or two exposures best convey or capture the motion—before you take the picture—is the key. Once you are armed with this knowledge, you can begin to fully explore the truly endless road of creatively correct motion-filled exposures.

Since every picture-taking opportunity allows for no less than six possible aperture and shutter speed combinations, how do you decide which combination is the best? Think about what you want to do. Do you want to freeze action? Fast shutter speeds—1/250, 1/500, and 1/1000 sec.—are the creative force behind "frozen" images. Do you want to suggest motion via panning? Then you should call upon shutter speeds of 1/60, 1/30, and 1/15 sec. And, those superslow shutter speeds (1/4 sec. to 15 seconds) are the creative force behind images that imply motion, such as a waterfall or the wind blowing through a field of summer wheat.

And keep in mind that when it comes to motion-filled subjects, you must first think about which creative shutter speed will convey the motion before you in the way that you want. Then and only then should you even begin to worry about the second-most-often-asked question: Where should I take my meter reading from? I'll address this question throughout many parts of this book, but the good news is that the built-in light meters found in today's cameras do a fantastic job of rendering a correct exposure, even when using the semiautomatic modes, such as Aperture Priority or Shutter Priority.

WHEN SHOOTING THIS SIMPLE COMPOSITION *of an S-curve on Interstate 5 approaching down-town Seattle, I was presented with six possible options for recording a correct exposure, three of which you see here. In terms of their quantitative value, all three of these images are exactly the same exposure; however, you can clearly see that they are vastly different in their creative interpretation, with the creative emphasis on the use of motion.*

It is always my goal to present motion-filled subjects in the most motion-filled way, and more often than not, when there is a motion-filled scene, the longer the exposure time, the more prominent the motion effects. I shot the first example (bottom left) at f/4 for 1/2 sec., the second (bottom right) at f/8 for 2 seconds, and the third at f/16 for 8 seconds.

An exercise such as this is truly eye-opening. The next time you head out the door to shoot city lights at dusk, you shouldn't have any hesitation about using the slower shutter speeds, since as you can see, the exposure with the slowest shutter speed yielded, in my opinion, the best effect. (Note that this is not bracketing, since they are all the same exposure in terms of their quantitative value.)

All photos: Nikon D2X with Nikkor 200–400mm zoom lens at 400mm, tripod, ISO 100, Cloudy WB

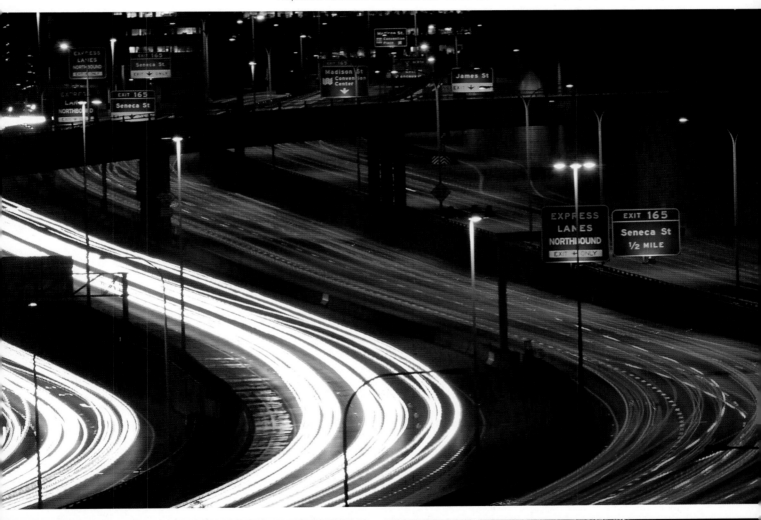

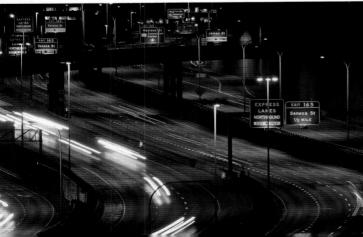

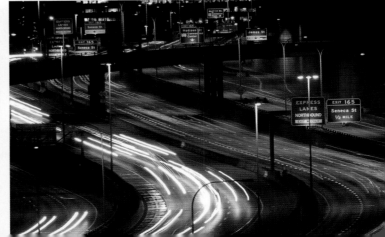

GOING TO EXTREMES

As you begin to digest more and more information in this book, you'll soon see that motion-filled opportunities are everywhere—and that in capturing them you find yourself on either end of the shutter speed spectrum, using either fast shutter speeds to freeze the action in crisp, sharp detail or slow shutter speeds to blur or imply the motion that was there. There's rarely a middle ground when it comes to the moving world, and with that in mind, it won't be long before you discover that most of your action (and also low-light) photography time is spent at either anywhere between 1/500 and 1/1000 sec. *or* anywhere between 1/4 sec. to 8 seconds.

WITH MY CAMERA AND ZOOM *mounted on a tripod, I shot the first image (opposite, left) at f/4 for 1/500 sec. and the second image at f/22 for 1/15 sec. The decision of exposure and which shutter speed to use will always be yours, so why not make it a point to make the most deliberately and visually compelling creative exposure possible?*

Opposite, left: 80–400mm Nikkor zoom lens at 300mm, tripod, 1/500 sec. at f/4; opposite, right: 80–400mm Nikkor zoom lens at 300mm, tripod, 1/15 sec. at f/22

VALUABLE LESSON: THE LARGEST LENS OPENING ALLOWS THE FASTEST SHUTTER SPEED

In keeping with the idea of extremes, note the following: (1) You will always attain the fastest possible shutter speed at any given ISO when you use the largest possible lens opening, and (2) you will be able to attain the slowest possible shutter speed at any given ISO by using the smallest possible lens opening.

This is one of the best lessons I know and one that I've offered to countless students over the years in my on-location workshops and my online photo courses. It's very revealing and, not surprisingly, will lead you further into the world of creatively correct motion-filled exposures.

To practice this concept do the following: Choose a moving subject, such as a waterfall, a child on a swing, or something as simple as someone pounding a nail into a piece of wood. Set your camera to Aperture Priority mode and your ISO to 100 (or 200 if that's the lowest your camera offers); then set your aperture wide open (f/2.8, f/3.5, or f/4) and take an image of the action before you. You have just recorded an exposure at the fastest possible shutter speed based on the ISO in use, the light falling on your subject, and, of course, your use of the largest possible lens opening.

Now stop the lens down 1 full stop. So, if you started at an aperture of f/2.8, go to f/4; if your lens starts with f/4, go to f/5.6. Then, once again, make another exposure. Do this over and over again, each time with the aperture set to f/8, then f/11, then f/16, and finally f/22. Each time you change the aperture by a full stop, your camera does a quick recalculation and offers up the "new" shutter speed to maintain a correct exposure. And since you're stopping the lens down with each full-stop change in aperture (making the hole in the lens half as big as it was before), your shutter speed has now doubled in time to compensate—or, in other words, your shutter speed is becoming progressively slower. The slower your shutter speed, the more likely that the resulting image will exhibit some blurring effects, since the shutter speed is too slow to freeze the action.

And what about waterfall shots? That well-known cotton candy effect you can get with the water doesn't start until you use apertures of f/16 or f/22. Likewise, isn't that motion-filled image of your child on the swing really something? Note how the faster shutter speeds freeze your child in midair but the slower shutter speeds turn your child into a ghost. Take notes on your exposures and make the discovery as to which combination of aperture and shutter speed resulted in the most creatively correct photographic exposure.

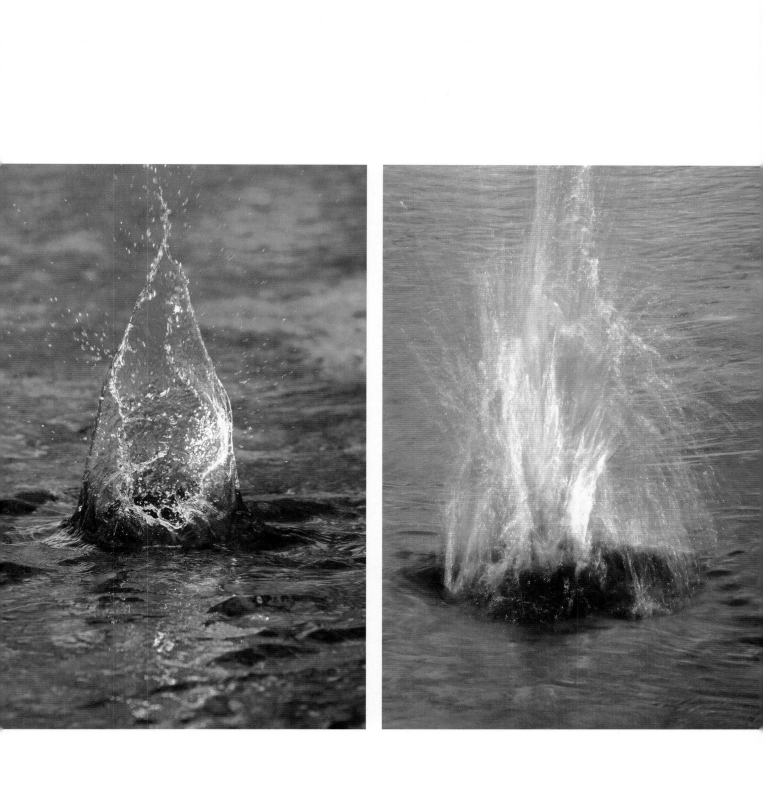

THE MYTH OF ISO EXPOSED

Some of you may be wondering why I haven't taken into account the importance of ISO when talking about motion-filled images, particularly those that freeze action. To address the *myth* that a high ISO is needed and preferred by professional photographers worldwide, I want to offer up a CliffsNotes version of ISO's very important, but also sometimes misunderstood, role in exposure. Simply put, the ISO you choose will determine which of the six combinations of apertures and shutter speeds you can use in creating a correct exposure. I want you to think of ISO as a group of carpenters who respond to light and, in turn, build a house with that light—or in other words, they record an image.

Clearly, if you were part of a group of one hundred carpenters and your friend were part of a group of two hundred carpenters and I were a part of a group of four hundred carpenters whose job it was to build sixteen houses, which group, in all likelihood, would get the houses finished quicker? Obviously, my group—all four hundred strong of us. For the sake of illustration, let's say it would take one hundred carpenters sixteen days to build sixteen houses. How many days would it take two hundred carpenters or four hundred carpenters to build these same sixteen houses? Eight days and four days respectively.

And how does all this apply to action photography? Well, if you expect to record—in exacting sharpness—the power of an ocean wave slamming hard against the rocky cliffs or a motocross racer flying over the rain-soaked hill, you will need all the "carpenters" you can get your hands on, right? Wrong! Just because four hundred carpenters (ISO 400) can build sixteen houses two times as fast as two hundred carpenters (ISO 200) and four times as fast as one hundred carpenters (ISO 100), it doesn't necessarily mean the quality is better. In fact, when it's all said and done, each house, at least on the surface, looks exactly the same! But—and here is the part that's critical to understand—once that house is finished, all eight hundred, four hundred, or one hundred carpenters will be moving in with you *permanently*. If you think one hundred people in a house can make some noise, imagine how much more noise eight hundred people can make!

Noise, or what in photographic terms is called *grain*, begins to be a real problem whenever you use

FREEZING ACTION AT ISO 100, 200 & 400

So, here's a question: If you could end up with a razor-sharp action-stopping image by using ISO 100, would you? Take a look at this table to discover how you can freeze most action subjects with as little as ISO 100, resulting in an image that's flawless. The following exposure calculations are based on sunny lighting conditions with a frontlit or sidelit subject, and to be clear, this same lighting condition applies to each ISO.

And one important point: I am fully aware that sometimes depth of field issues are also a concern when you're freezing action. When you want to add a bit more depth of field plus maintain a fast, action-stopping shutter speed, you may feel inclined to resort to the higher ISOs. I've certainly found myself doing just that over the years, especially when I was shooting film. However, in this truly wonderful age of digital, I've discovered a way to record exposures with both a depth of field and a shutter speed normally reserved for ISO 200 or ISO 400—*without* having to actually resort to those higher ISOs. See page 138 to learn this great trick. The technique does require that you shoot in the raw format, which for some is not welcome news due to the time (although minimal in my mind) spent in postprocessing. If you're not a raw shooter, but rather a JPEG shooter, then by all means, use the higher ISOs when necessary.

ISO 100	ISO 200	ISO 400
f/4 for 1/1600 sec.	f/4 for 1/3200 sec.	f/4 for 1/6400 sec.
f/5.6 for 1/800 sec.	f/5.6 for 1/1600 sec.	f/5.6 for 1/3200 sec.
f/8 for 1/400 sec.	f/8 for 1/800 sec.	f/8 for 1/1600 sec.
f/11 for 1/200 sec.	f/11 for 1/400 sec.	f/11 for 1/800 sec.
f/16 for 1/100 sec.	f/16 for 1/200 sec.	f/16 for 1/400 sec.

ISO 100

ISO 200

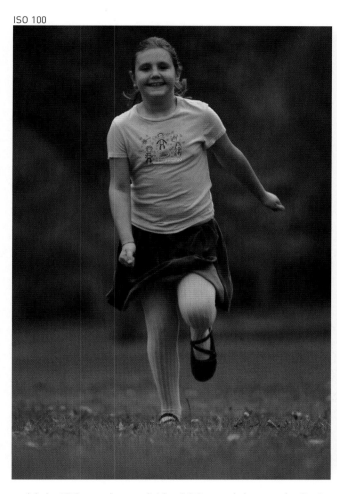

a high ISO such as 640, 800, and beyond. Grain affects overall sharpness and even color and contrast. In addition, when you employ eight hundred carpenters (ISO 800), you often end up using smaller lens openings, which, in turn, have this uncanny ability to make "things" even clearer. So, not only has the overall depth of field (sharpness) increased from front to back, but because of the added sharpness, you have made the noise that much more apparent.

On closer inspection of those houses that were built in four days with eight hundred carpenters (ISO 800), you begin to see minor imperfections—cracks in the woodwork, flaking in the plaster, and an overall

ON THIS AND THE NEXT TWO PAGES, *these five images of my daughter "flying" toward me at the local park prove my point about the myth of ISO. In all five shots, I used the same action-stopping shutter speed of 1/250 sec. but used a different ISO and, subsequently, a different aperture in order to keep the exposure constant. As my ISO increased, so did the visual "flaws" (increased noise and, in this case at least, some unwanted increase in depth of field).*

In the first image (left) note the out-of-focus tones that surround her, particularly behind her. The exposure was ISO 100 at an aperture opening of f/4 for 1/250 sec., so there's very little depth of field/sharpness beyond her. Note how the area of sharpness around her increases as the ISO gets higher. You can see it clearly in the grass both in front and behind her foot and also in the background, which becomes more defined. In addition, the use of ISO 1600 really brings on the noise. If noise is going to be made about your picture-taking talents, wouldn't you prefer it to be "joy and excitement" rather than the "noise" (i.e., graininess) that comes from using a high ISO?

ISO 400

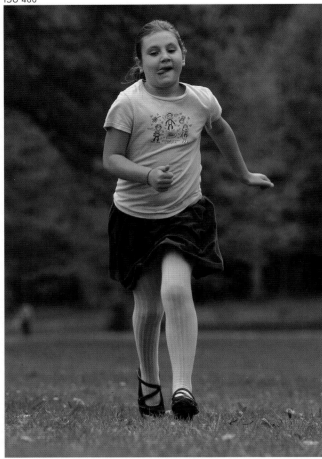

ISO 800

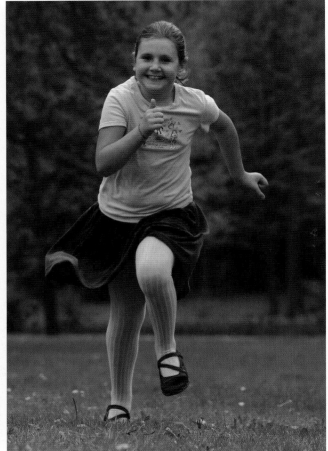

color that may not be as rich. Such is the power of grain/noise. In addition to seeing more unwanted detail in your actual subject, you may also see that more detail has been revealed *around* your subject, such as the unsightly house beyond the backyard, for example. Having to use too small an aperture when shooting with high ISOs allows you to use smaller lens openings (*f*/16 or *f*/22, for instance), and sometimes, this will result in a composition that offers up far too much depth of field. When you compare the houses that were built in sixteen days to those built in four days with one hundred carpenters (ISO 100), the woodwork, plaster, and paint appear to be flawless,

and if there are any unsightly houses nearby, you either don't notice them at all or find them to be bare-ly a distraction.

My point in all of this is to simply say that most of those fleeting moments you wish to record on film or digitally can be captured at shutter speeds that are well within your reach—even when you use ISO 100. The need to go out and buy high-speed film (for example, ISO 400, 800, or 1000) or to all of a sudden switch your ISO from 200 to 800 just because you want to freeze the action before you in exacting sharpness is a myth! Camera manufacturers are making some great strides in noise reduction. In particular,

ISO 1600

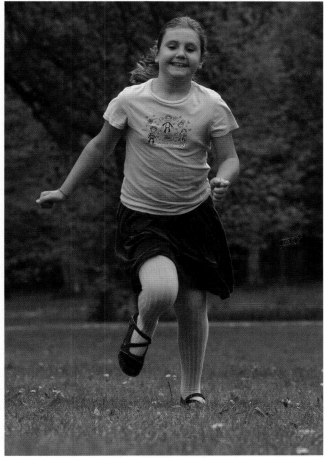

WHAT'S THE REAL PROBLEM WITH ACTION PHOTOGRAPHY?

I'll be the first to admit that it's tough to get a really good action shot, especially of sports. The subjects rarely stop moving, and when they do, the interesting action stops, as well. Still, since you can find some fairly advanced autofocus programs in many cameras, keeping subjects in focus is rarely the problem.

The real problem is keeping the subject inside that viewfinder, filling the frame with it without cutting off heads, hands, or feet. So, it's not the absence of a crystal-clear and sharp image that is the problem; rather, it's the absence of your subject inside the frame. Overcoming the problem of *not filling the frame* isn't an issue of ISO or shutter speed. It's a completely different hurdle that's easy to overcome, and throughout this book I'll offer up ideas about how to compose action-filled scenes with the emphasis on filling the frame.

Additionally, this book explores night and low-light photography, and it does so on the assumption you'll be shooting with ISO 100 or 200. However, if you're shooting at night, in low light, or indoors and you can't or don't wish to use a tripod, you can certainly opt to use ISO 800 or 1600. The primary purpose of these high-speed ISOs is not so much to freeze action but to shoot in low light. Still, as you'll see, I shot more than 90 percent of the images in this book with ISO 100, including the action-stopping images that are often shot at 1/500 and 1/1000 sec.

Canon and Nikon, the two industry heavyweights, have several digital camera models that deliver some truly low to moderate noise levels at the high end of their ISO spectrum, from 800 to 2400. The temptation is there to become seduced by the low noise levels found at these higher ISOs, and some of you might even think that you can now say good-bye to your tripod—yikes!

The use of higher ISOs means, in many cases, the use of smaller lens openings, which, in turn, increase depth of field. The shot you made of your son's winning touchdown at Saturday's football game, with ISO 1000 at *f*/16 for 1/1000 sec., is now competing for the eye's attention due to the increased depth of field found at *f*/16. Sure, we see your son making the catch in the end zone, but we also see the hot dog vendor over his shoulder, up in row 15. Had you shot instead with ISO 200 at *f*/5.6 for 1/1000 sec., there would be no evidence of a hot dog vendor since the much shallower depth of field of *f*/5.6 would have been limited to your son's touchdown. Furthermore, the use of higher ISO settings also *decreases* your opportunity for using longer shutter speeds, and I'm sure that by the end of this book, you will want to take full advantage of the literally hundreds of creative opportunities offered up when using slow shutter speeds.

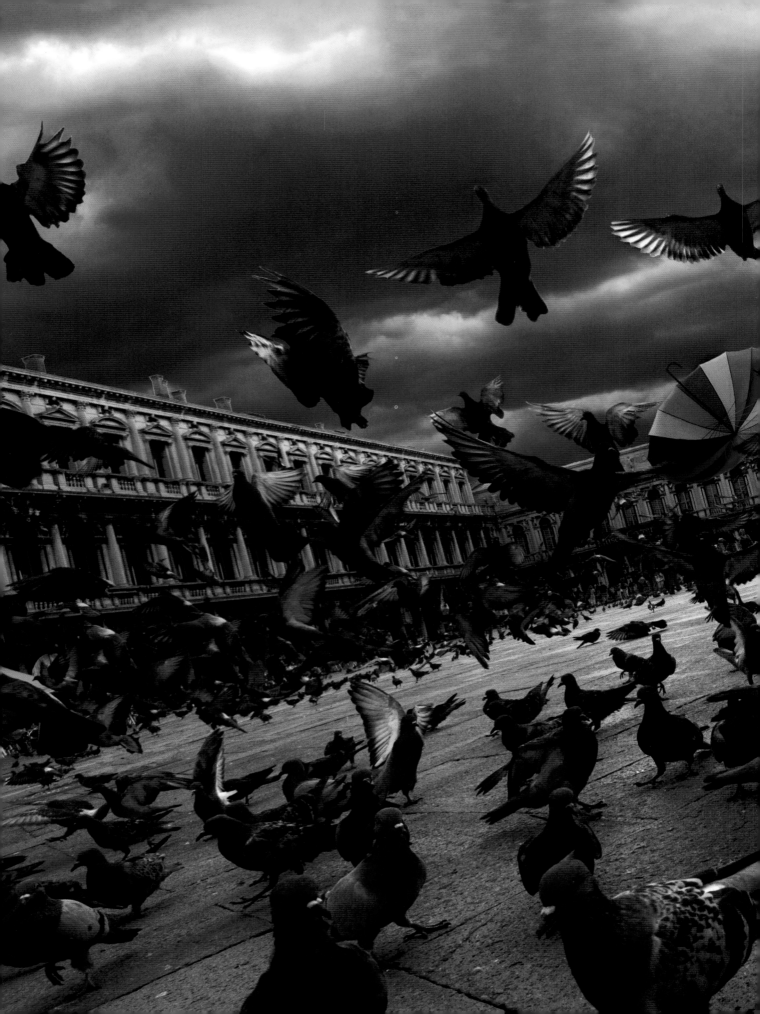

FAST &
MODERATE
SPEEDS

FREEZING ACTION

f I came to your house and chatted with you for a whopping 1/100 of a second, you would no doubt say, "Well, he was here, but in the blink of an eye, he was gone!" And why not, since 1/100 of a second is fairly darn quick? Now imagine if I dropped by your house for only 1/800 of a second. Yikes! I'd be gone before you even knew I was there.

So, just how fast is 1/100 of a second? Believe it or not, it's ten times faster than the blink of an eye, which, in case you were wondering, averages around 1/10 of a second. And since 1/100 of a second is ten times faster than the blink of an eye, you would think that should be plenty fast enough to freeze the action of most anything that's on the move—but, of course, you'd be wrong. Read on.

There are many keys to recording great action shots: lens choice, distance to the subject, direction of the subject (i.e., is it moving toward you, or from right to left or left to right past you, or up and down in front of you), ISO, and, of course, shutter speed. Next to ISO, choosing the right shutter speed is the most important element. For most outdoor action-filled shots, shutter speeds of 1/500 or 1/1000 sec. are the norm, and for many experienced shooters, getting to these 1/500 and 1/1000 sec. exposures is often the direct result of using the right ISO.

Choosing the right ISO doesn't have to be hard. On page 18, I spoke about how easy it is to get action-stopping speeds with ISOs between 100 and 400. I hope you will embrace this advice, because using anything higher will, in all likelihood, *not* render a better action-stopping image—but it will, in all likelihood, render a great deal more depth of field, if not more noise. As I mentioned before, I shot more than 90 percent of the action-stopping images in this section with ISO 100, and the remaining photos were shot with ISO 400.

As I mentioned previously, another consideration with action is distance. Many shooters talk about the photographer-to-subject distance, but how close you are to the action is really a moot point. I can be fifty feet away from that mountain biker in midair coming over that hill, but if I'm using a 400mm lens from that fifty-foot distance, then I may as well be right in front of him. In other words, if my frame is more than 75 percent filled with the subject, then as far as I'm concerned, we are sharing the same bed—and when you share a bed with anyone, you are close!

Assuming you are indeed "sharing the same bed" with your subject, you have to then consider another important factor that I mentioned earlier, before you can determine which shutter speed is best: Is the frame-filling action coming toward you or is it moving side to side—or even up and down? When action is coming toward you, you can get away with using a shutter speed of 1/250 sec., but when the action is moving side to side or up and down, shutter speeds between 1/500 and 1/1000 sec. are the norm, and in some cases, you may even have to resort to 1/2000 sec.

EQUIPMENT

I'm often asked by my students which pieces of equipment, besides the motor drive (see page 29), I *cannot* live without, and my answer may surprise you: I cannot live without my tripod, my LEE 4-stop graduated ND filter, my polarizing filter, my 12–24mm super wide, my 70–180mm macro, my 200–400mm, my Nikon Infrared Remote, my Bogen Magic Arm, my Bogen Super Clamps, and my Bogen suction cup.

The Nikon Infrared Remote and the Bogen Magic Arm and Super Clamps allow me to execute those image ideas that oftentimes come to me at all hours of the night, waking me from my sleep. In other words, at 2:00 A.M. when I wake up asking myself, "What if . . . ?" or "Could I possibly use . . . ?" these pieces of equipment enable me to fulfill my vision.

There are many other brands that compete very well with the Nikon Infrared Remote, PocketWizard being one of them, and there are some lesser-known brands for less money that accomplish the same thing. At the time I bought my Nikon remote, there weren't a lot of other choices out there, so if you're looking to invest in a remote triggering device, shop around and you might discover that you can find something akin to PocketWizard at a place like Adorama in New York for under $100.

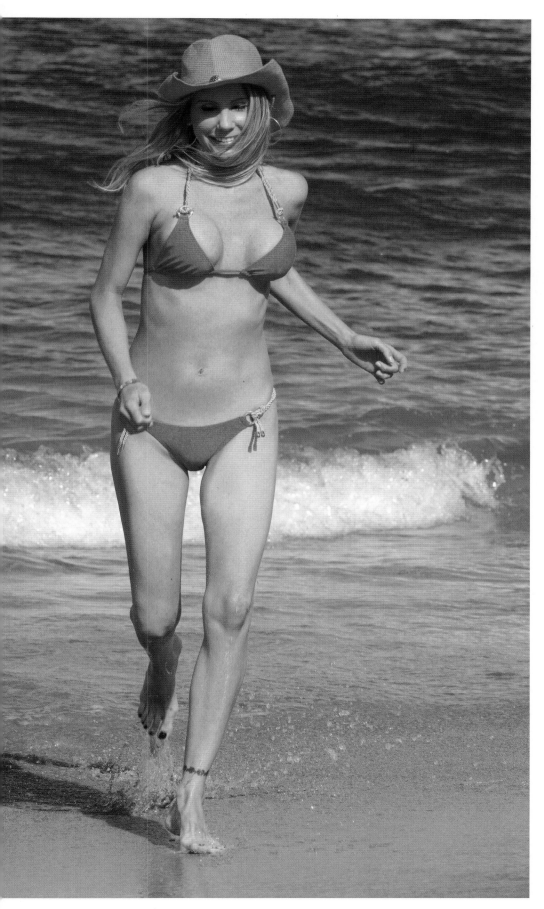

MY WIFE, KATHY, *is one of those people who seems to keep dodging the "aging bullet." Not that being forty years old is "old," but she still gets carded on occasion when we go to nightclubs or when she tries to buy alcohol at the store. I shoot a lot of stock photography, and fortunately for me, when I have need of a beautiful model, I have only to turn to my wife.*

On this particular morning, while vacationing in Hawaii and after buying her a brand new swimsuit, she willingly played the part of "the beautiful, healthy, vivacious woman who enjoys life to the fullest." No doubt the early-morning warm and golden glow of frontlight against the backdrop of a tropical blue ocean also speaks to the issue of a healthy lifestyle, but more than that is the simple act of her running. When we see anyone running in the park, for example, we all think health and vitality. And running also means the use of a fast shutter speed if I'm going to have any success in freezing her in midstride. Since she was running toward me, I could easily capture an action-stopping image at 1/250 sec. Handholding my camera with the ISO set to 100 and the shutter speed set to 1/250 sec., I simply adjusted the aperture until f/11 indicated a correct exposure. And of course on my Nikon D2X, I had set the motor drive to CH (continuous high) mode, which is called Burst mode on some cameras. The image here was one of seven taken in a sequence.

Nikon D2X, 70–200mm lens, ISO 100, 1/250 sec. at f/11

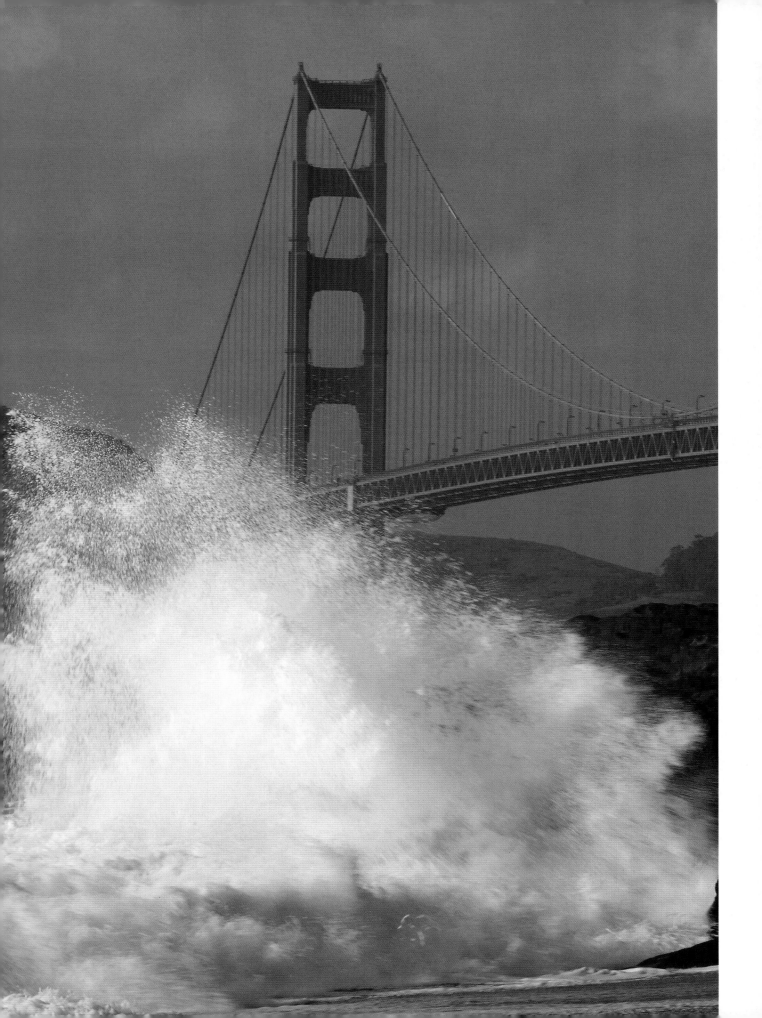

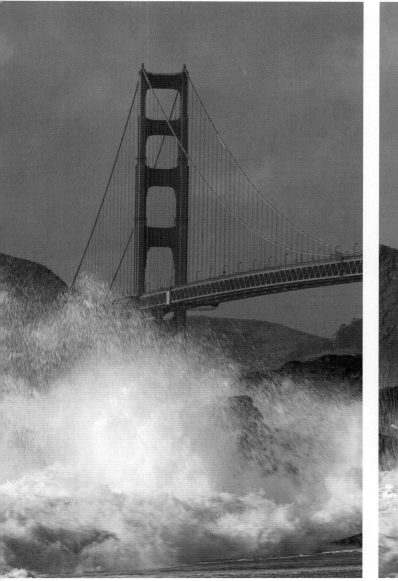
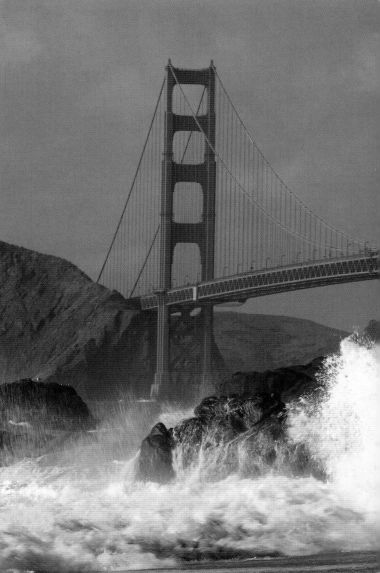

YOU CAN TAKE ONE *of the more classic shots of the Golden Gate Bridge from the beach below as you look north toward the Marin Headlands. I fired more than seven shots (three of which you see here) of this large incoming wave, and because I was in CH mode (Burst mode on other cameras) with my Nikon D2X, I was assured of record-ing the* one *most important shot of the wave exploding at its peak.*

Since light meters can be fooled by white areas, I chose to take my meter reading from the somewhat blue sky overhead. And, since I knew I wanted to shoot at an action-stopping speed of at least 1/500 sec., I first put my shut-ter speed to that setting and then, with the camera and lens pointed to the sky between the bridge's two towers, I simply adjusted my aperture until f/8 indicated a correct exposure.

If you're accustomed to using your camera in either Shutter Priority or Aperture Priority mode, the easiest route to a correct exposure would be to go to your autoexposure override, add +1, and then simply aim and fire. No need to take a reading off of the bluish sky. Of course, when you're done shooting this white wave, you'll want to remember to reset the autoexposure override to 0.

You might be asking yourself why I bother going to the trouble of using manual exposure. The answer is twofold: (1) It's the way I learned to use a camera thirty-two years ago (old habits die hard), and (2) there continue to be many lighting situations in which setting a manual exposure is the shortest route to success and consistent exposures. Although this book does discuss exposure to some degree, it doesn't tell you how to use your camera in manual mode. If you don't know how to set an exposure in manual mode or you don't quite understand the mechanics of exposure when using Shutter or Aperture Priority mode, I would suggest taking a look at my book Understanding Exposure.

70–200mm lens, tripod, ISO 100, 1/500 sec. at f/8

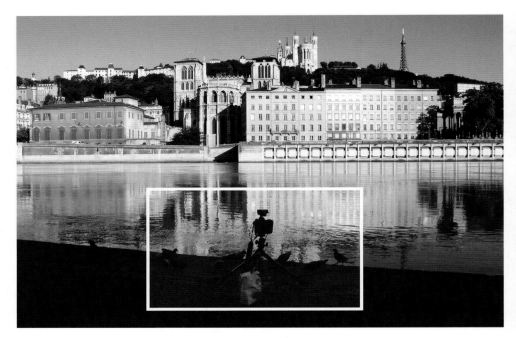

JUST HOW COULD I GET THOSE ANXIOUS PIGEONS to come in really close to me while I was lying low on my belly at the edge of the Saône in Lyon—and to fly up into the foreground of my composition at just the right moment? I couldn't, since my presence at the base of my camera would have scared away even the most confident pigeon in France. But with the aid of my Nikon Infrared Remote triggering device, I could. So, with the Nikon receiver mounted on the camera's hot shoe, I simply took a seat about fifteen feet away from the camera and tripod and prepared to fire the shutter with the sending unit in my hand.

I set out a feast of French bread and cookies just below my shot, waited for the pigeons to come, and then fired the sending unit. The sound of the camera's release and motor drive was enough to startle the pigeons and cause them to take flight. Normally, in a situation like this, I am able to fire off about 6 to 8 shots before the subject moves out of camera range, and in a matter of minutes the pigeons had returned to the feast, so the process started all over. On this particular morning I took a total of 88 shots.

This was an easy exposure in that the scene was lit by simple frontlight, all evenly illuminated. No dark shadows or bright highlights that might otherwise fool

the meter, so with my aperture set to f/8, I simply adjusted my shutter speed until 1/500 sec. indicated a correct exposure. But, before shooting, and in anticipation of the birds flying up into the foreground of the frame, I felt that a shutter speed of 1/2000 sec. was in order if I was going to come close to freezing the flapping of their wings without the slightest hint of a blur. Therefore, I set the shutter speed to 1/2000 sec. even though my light meter was now indicating a 2-stop underexposure, knowing that I could easily recover those stops in postprocessing (see page 138 for more on this technique). As the image to the right shows, I did capture their wings with exacting sharpness.

Note that I didn't open up the lens to f/4 at 1/2000 sec. because I would not have attained the front-to-back depth-of-field sharpness I needed to make this shot work. Also note, so that there is no confusion about my correct exposure, that the stark silhouetting of the pigeons is due to the fact that my exposure was set for the much brighter and stronger early-morning frontlight falling on the buildings across the river, not for the open shade falling on the pigeons. This is a lighting situation that I favor and often look for.

ISO 100, 1/2000 sec. at f/8

THE MOTOR DRIVE

Nowhere else in the act of image-making is the use of a motor drive more important than in action photography. Most cameras today come fully equipped with a built-in winder or motor drive, allowing photographers to reach a higher degree of success when shooting action-filled scenes. (This is often known as Burst mode on digital cameras.) Without the aid of a motor drive or winder, it is often a hit-or-miss proposition as you try to antici-pate the exact right moment to fire the shutter. With the aid of a winder or motor drive, you can begin firing the shutter several seconds ahead of the peak action and continue firing until a second or two after the action has stopped—and it's a very safe bet that one, if not several, exposures will be successful.

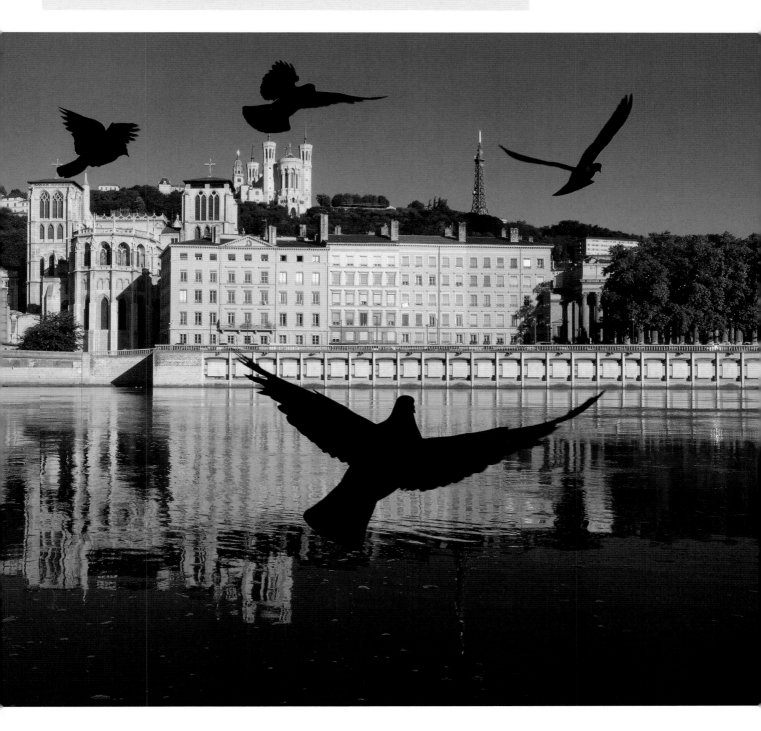

TRUTH BE TOLD, *I have never been a big fan of flash, and it all goes back to my early years as a photographer. I not only found flash unflattering to my subjects, but for years, I could never fully understand how flash "worked." That, of course, had to change, and it did, since it was an absolute necessity to succeed as a commercial photographer. But, whenever possible, I will still always opt for* available light. *And one of my favorite setups finds me in the great outdoors, taking full advantage of* midday light. *Yes, you read that right. Bryan Peterson shoots during that god-awful time of day called high noon, and you know what? You can actually get some really cool, studio-flash-like exposures doing so.*

The image at left shows my setup for food photography: a simple vase filled with bubbly mineral water sitting atop an open reflector (silver side up), and seamless blue paper for a backdrop (which can be found at any art supply store). I also mounted my camera with macro lens on a tripod. With an ISO of 200, I was able to record a correct exposure at f/10 and 1/500 sec., but due to the magic of raw format, I actually chose to shoot these fruits 2 stops underexposed at f/10 and 1/2000 sec., knowing full well that I could recover those stops in postprocessing by adjusting the Exposure slider in Photoshop until I got a correct histogram (see page 138 for more on this).

Depth of field was a concern here due to my close focusing distance, so this is one of those times when I had to employ a 1-stop-higher ISO (200), which allowed me to record both the faster shutter speed and the needed depth of field. At ISO 100, f/7.1 would not have been enough.

Once I was all ready to go, I simply asked my daughter Sophie to drop a single strawberry. After repeated tries, I took a moment to review the results, and sure enough, I had far too many images in which the strawberry was either not far enough into the composition or had dropped too far into the bottom of the frame. But mixed in amongst all of those missed shots, I also found one or two jewels. Then I thought, why stop at one strawberry when you can try three at a time? (I love the power of three, in case you are wondering why I chose three.) After several attempts, I recorded an image of three falling strawberries as they broke through the surface of the water.

Note the lighting in both of these exposures. The strawberries are lit from above and below: The sun overhead lights them from the top, and the reflected sun bouncing up off the silver reflector lights them from underneath. Who says you need strobes? Obviously, too, this setup is not limited to strawberries. Let your imagination run wild and soon you will be dropping almost anything that will fit into your vase.

ISO 200, 1/2000 sec. at f/10

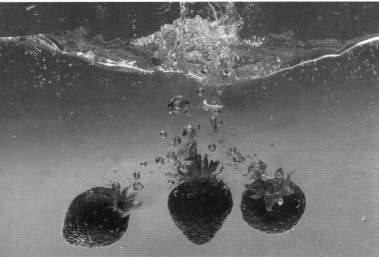

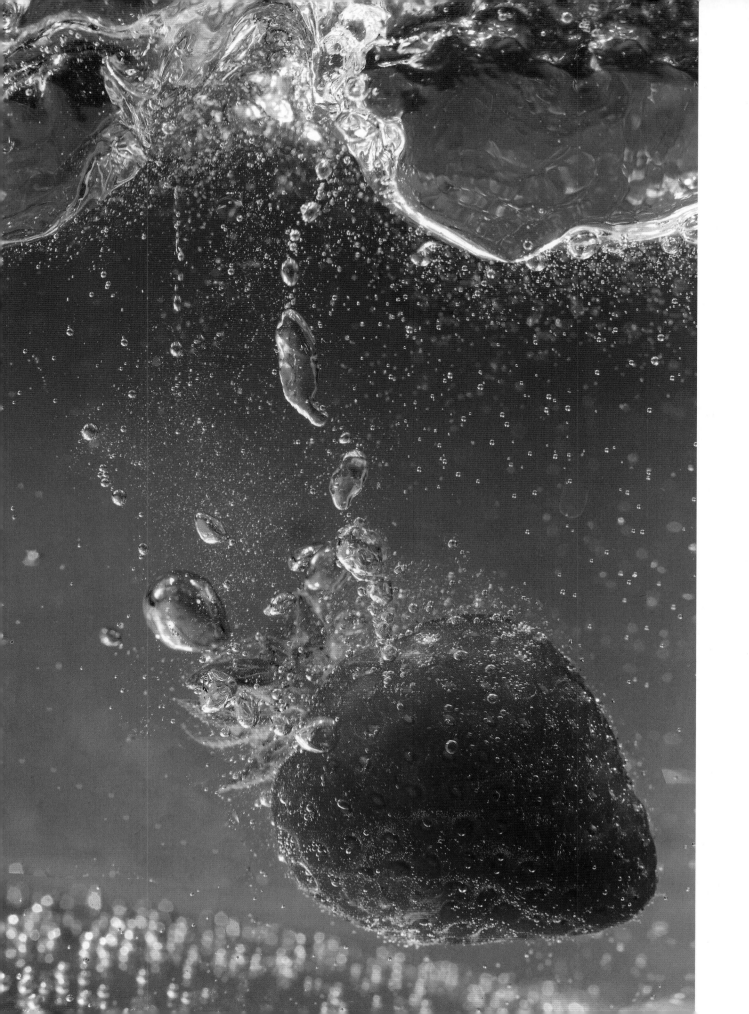

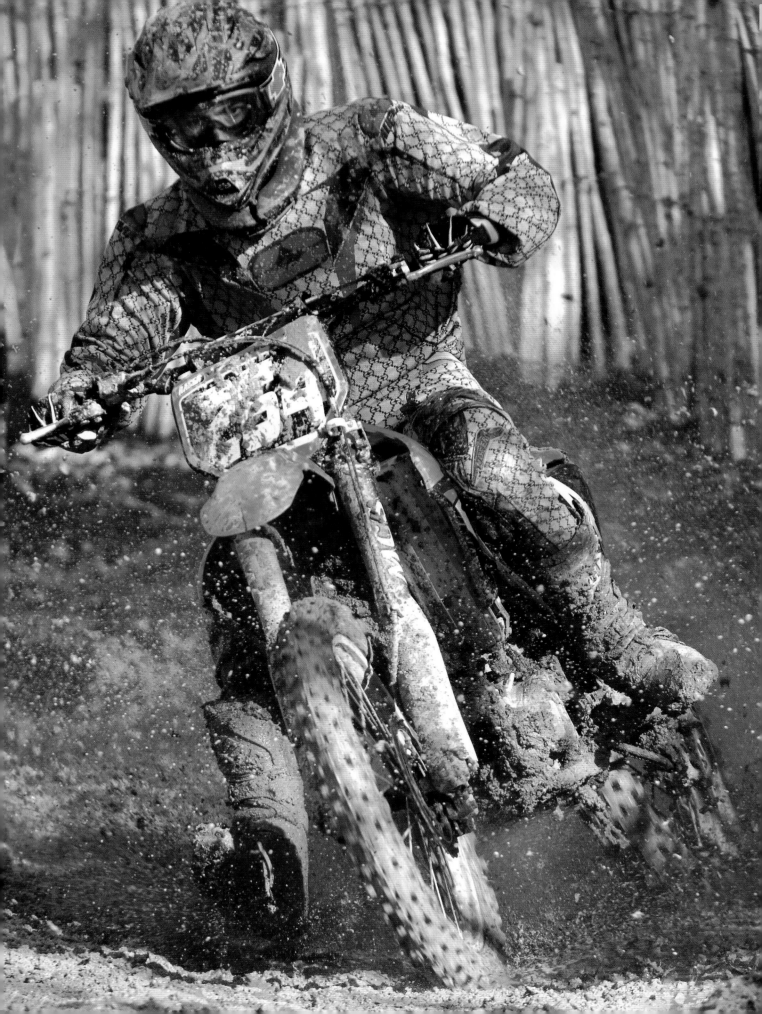

1/250 SEC.

No matter what action you're photographing, if that action is coming at you, you can safely shoot at 1/250 sec. This is especially true with regard to sports. The hundred-yard dash at a track-and-field event, cars on the straightaway at a NASCAR race, the lone swimmer nearing the end of the pool, the tight end running toward the end zone, or the number four greyhound crossing the finish line are just a few of the many examples that await the use of 1/250 sec.

I HAVE ONLY BEEN *to one motocross race, and it's safe to say it won't be my last! I don't know if it's the norm at all motocross events, but at least at this one, I was able to get ridiculously close to these guys. I hadn't been that near the action of a sporting event since shooting an NFL game in Pittsburgh back in 1997. Granted, I walked away quite dirty, but it was worth all the mud that came flying my way.*

On one part of the track, the bikers would come around a corner and hit this straightaway before making another turn that would see them flying up and over one of the many hills. Each and every rider almost always seemed to follow the same deep ruts in the dirt track, so this made it extra easy for me—all I had to do was focus on that spot and fire away as each rider came through.

With my camera and lens mounted on a monopod, I chose an action-stopping speed of 1/250 sec., since the riders were coming toward me. I then adjusted my aperture until f/11 indicated a correct exposure, and over the course of only five minutes, I had recorded more than fifteen mud-caked motocross riders, one of which you see here.

70–200mm lens, monopod, ISO 100, 1/250 sec. at f/11

AMERICA & SPORTS: IT'S NOT JUST ABOUT HITTING THE BALL

America is a very sports-minded country. Not a weekend goes by that doesn't showcase two or more sporting events. Next to a baby's first few weeks of life and the family vacation, sports-related activities are probably the subjects most regularly photographed by families. Sports appeal to men and women, and both young girls and young boys play various sports, including soccer, basketball, and baseball.

Besides shooting the action of these and other sports, many amateur and pro photographers want to capture the participants' emotions. For example, a photographer may want to record the grimaces of two soccer players as their heads collide or the frightened expression of a cowboy flying through the air only seconds after being thrown from the meanest bull at the rodeo. Keep these details in mind as you train your lens on sporting events.

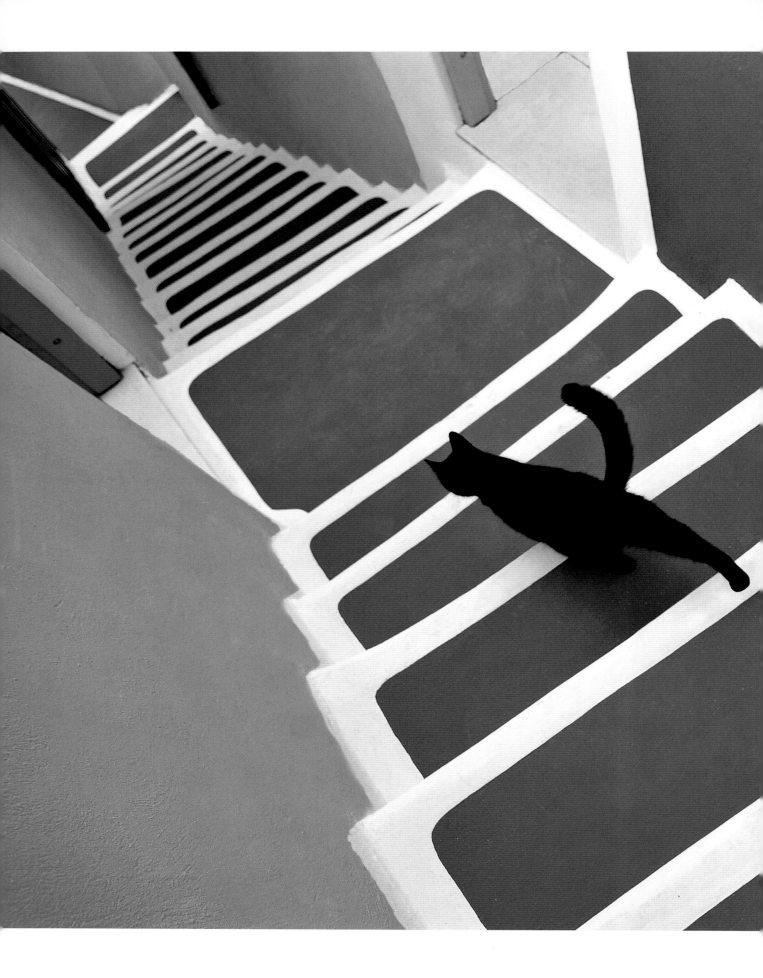

I HAD HEARD NOTHING but glowing reviews about the island of Santorini, off the coast of Greece, from many of my students, so I finally put Santorini on my workshop schedule one spring. Within minutes of arriving, I began to question what all the raves could have possibly been about, since I didn't "see" all that much. But once I arrived at my hotel, it became obvious why Santorini is thought to be one of the more beautiful islands.

And, of course, where would this island be without its cats? One of my favorite books, Cats in the Sun, showcases some really beautiful photography from the islands of Greece. In fact, it was my hope that I might come away from Santorini with several outstanding cat shots, much like those in that book. However, by the last day of the workshop, it didn't seem like it was going to happen—that is, until a black cat crossed my path.

I realize that for some, a black cat crossing your path is surely a bad omen; but for me, it proved to be a most fortunate thing. I followed this cat for some five minutes—stalking it, so to speak—until it finally found a resting place at the top of some colorful steps that led to several of the locals' homes. I moved to a short wall to the left of these steps, getting into a position that allowed me to shoot diagonally down on the stairs. All that remained was to wait till the cat took off, running down the steps, but it seemed rather content to sit atop the flight—so resigned, in fact, that it was soon lying down and about ready to take a nap when a large, barking dog came our way. That was all it took to get things moving.

17–55mm lens, ISO 100, 1/250 sec. at f/11

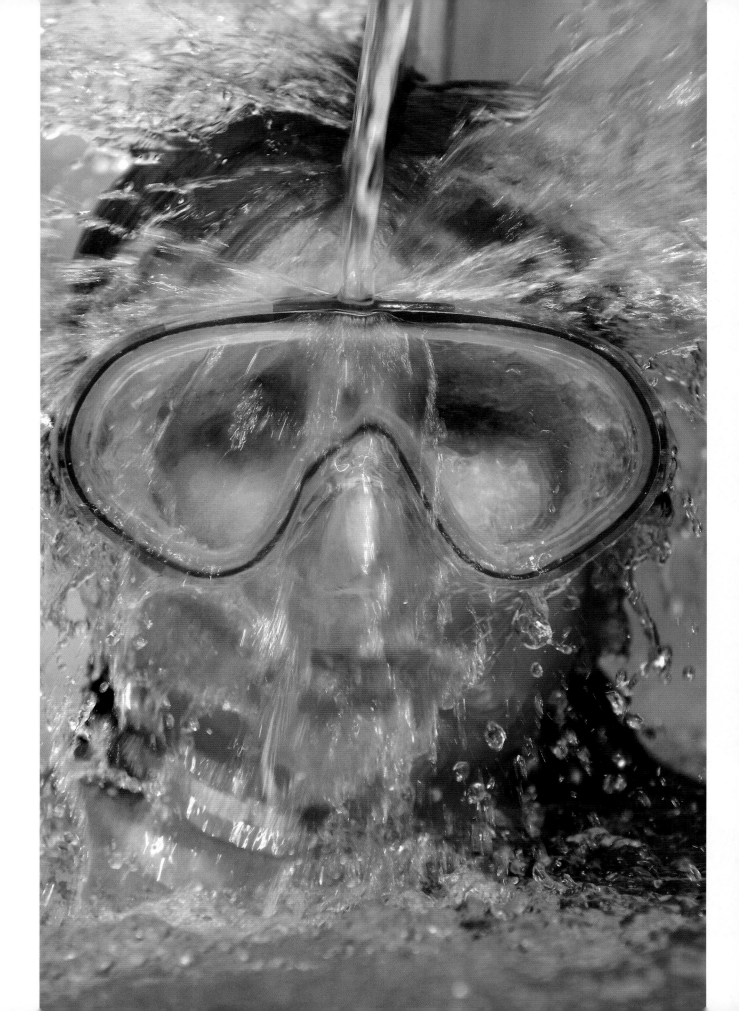

GO TO THE WATER

So where does one begin to get those great action shots? As the weeks and months unfolded in the production of this book, I began to realize just how much activity takes place in and around water. I began to wonder if I was simply blind to other action-filled opportunities, or if there was something magical about water in its ability to draw activity to itself.

My oldest brother, Bill, is an internationally known oceanographer who is often seen on the Discovery Channel offering up his insights into global warming. While working on this book and, once again, finding myself shooting another action-filled subject in the water, I was reminded of something we had talked about years ago: Water accounts for more than 70 percent of the earth's surface. That's almost three-quarters of the earth, so it should really come as no surprise that we are drawn to water. We swim in, splash, or dive into it. We surf, water-ski, Jet Ski, sail, and kayak atop it, and mountain bikers cycle through it. And it's that same water whose moisture eventually makes clouds, which, in turn, dump record snowfalls during the winter months—to the delight of skiers everywhere.

We wash with water, drink it, grow fruits and vegetables with it, and even put out fires with it! Water is everywhere, and it is a great source of action-filled photo ops.

WHEN I MADE THIS PICTURE *on the facing page, both of my daughters were enjoying their day of snorkeling in the swimming pool while I was on assignment in Cancún, Mexico. Taking a break from work, I was quick to join them, of course with my camera in hand. Rest assured, I was in the shallow end of the pool, with water up to only my waist. Nearby was a small waterfall that sent down a gentle cascade into the pool, and it was there that Chloë got "a head massage," as she called it.*

I was intrigued by this falling water as it met her head and fell and splashed around her. Handholding my camera, I set the shutter speed to 1/250 sec. and adjusted the aperture until f/10 indicated a correct exposure.

70–200mm lens, ISO 100, 1/250 sec. at f/10

FOLLOWING PAGE *Of the many workshops I offer around the world, none are more popular than the Vagabond workshops. These offer no set schedule, no itinerary per se. We just all meet at one spot, and over the course of four days, point the vans in the direction of the best light. Needless to say, it's not a workshop for those who don't like to get up early or who like to eat dinner on schedule.*

Of the two Vagabond workshops offered in 2006, the Maine/Vermont workshop, which took place in early October, was the most surprising in terms of what and where we found ourselves shooting one afternoon: harness racing at the Fryberg County Fair! Keep in mind, most of the students on this workshop were looking forward to shooting nature in all its vivid fall colors. So, when it was suggested that we give the Fryberg County Fair a shot, the reaction was, at first, somewhat tempered. A county fair would be a great place to try your hand at both panning and freezing action, I insisted. Several hours later, everyone was feeling quite enthusiastic and for good reason: The harness racing proved to be fertile ground for trying all sorts of different shutter speeds and their related effects (panning, zooming, spinning, twirling, and, of course, freezing action).

Sharing this corner of the track, we all were in position to fill our frame with the oncoming harness riders and their thundering horses. It was a simple shot really, since we all knew that our subject would be making the turn exactly here and that, since it was shortly after the race began, everyone would still be fairly bunched together. All we had to do was set an exposure that allowed the use of 1/250 sec. (for action coming toward us), prefocus on this spot, and have the camera set to Burst or continuous mode.

Nikon D2X, 70–200mm lens, ISO 100, 1/250 sec. at f/8

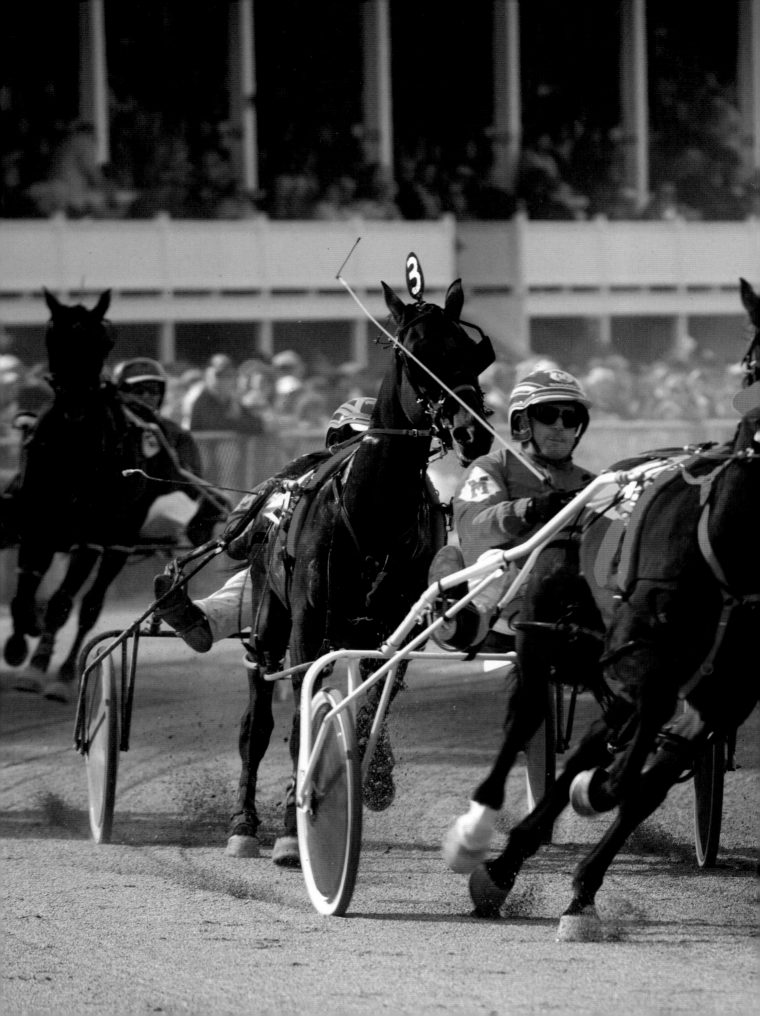

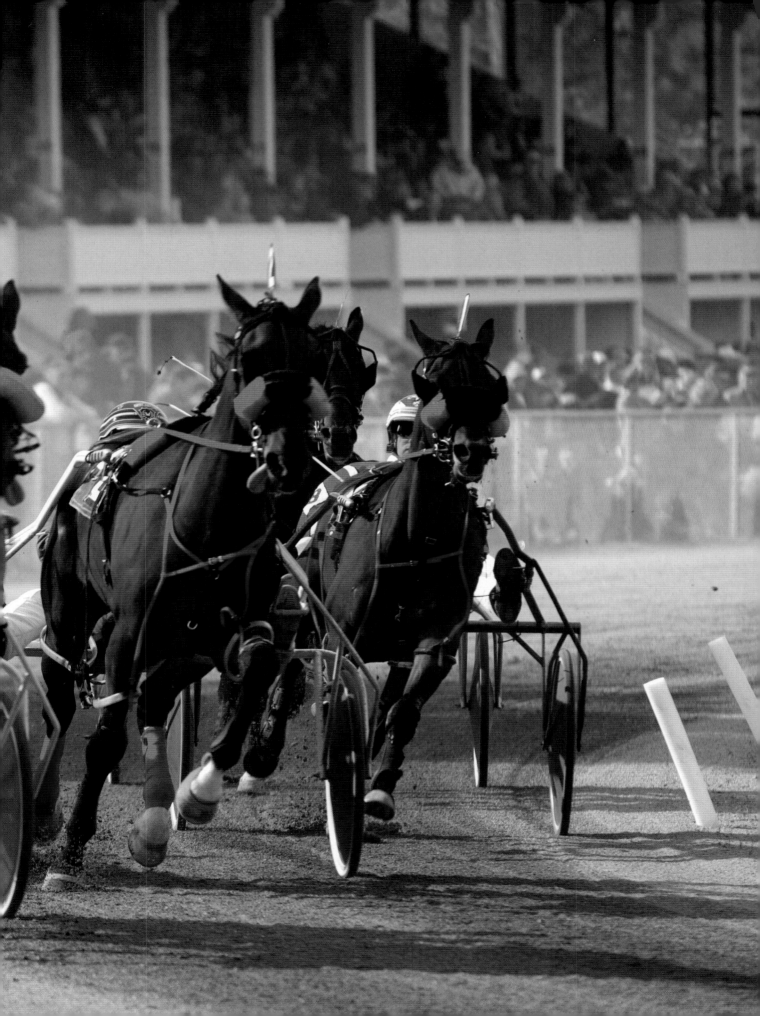

1/500 SEC.

It was in the summer of 1970 that I bought my first camera—a DeJur twin-lens reflex—at a garage sale for ten bucks. This had more to do with my oldest brother, Bill, who had been bemoaning the fact that I had been borrowing his Nikon F Photomic a bit too much over the course of the previous two months. I recall distinctly that the DeJur had a maximum shutter speed of 1/500 sec. and yet my brother's Nikon F had 1/1000 sec. Of course I felt cheated by this but soon discovered that there isn't a whole lot of action out there that you *can't* bring to a screeching halt at 1/500 sec.

The biggest challenge with my DeJur wasn't the absence of 1/1000 sec., but rather trying to compose my actions shots. Like many twin-lens-reflex cameras back then (the famous Yashica Mat-124 G comes to mind), the camera's viewfinder showed things as a "mirror image," meaning if the subject were moving left to right in my viewfinder, I had to move right to left to follow the action. Nonetheless, all it took was one "winning image" at 1/500 sec. of some friends playing flag football and I was hooked on the power of action-stopping compositions.

To the surprise of many amateur shooters out there, 1/500 sec. is often all it takes to get those action-stopping shots. You really don't need anything faster than that to get that shot of the base-runner slamming into the catcher at home plate or the long jumper spraying sand on landing.

Sure, there'll be times when your point of view may allow you to be within several feet of the action, and with your wide-angle lens at the ready, by all means, employ the faster shutter speeds of 1/1000 or 1/2000 sec. But remember that when you wish to freeze action coming in from the left or right—or action that is moving up and down—for the most part, 1/500 sec. is more than sufficient. The real key, when possible, is to prefocus on that spot, that area, where you know the action is headed—for example, that last hurdle near the finish line or the finish line itself—and, as the saying goes, let her rip!

MY DAUGHTER SOPHIE *has recently discovered the fun of jumping rope, and now every day has become "jump rope day." This is another action situation, for sure. Handholding my camera, set on Aperture Priority mode, I can get f/8 for 1/500 sec. It only took a few shots to get the full image (opposite), but before moving on, I wanted to also record the intensity of emotion in Sophie's face. Using the same exposure for this late-afternoon, frontlit scene, I simply moved in closer until I had filled the frame with just my daughter's "jumping face," and after more than a few tries, I was successful in recording her exuberant expression.*

70–200mm lens, ISO 100, 1/500 sec. at f/8

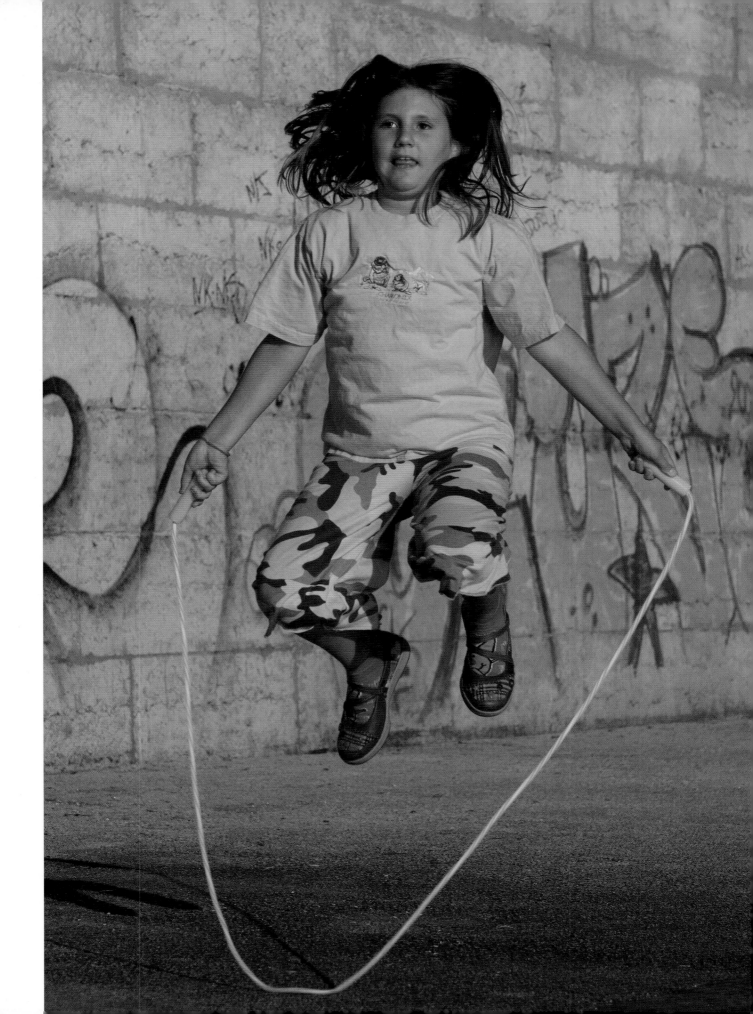

WHILE I SHOT DOWNWARD *from atop a ladder at the edge of a swimming pool, my friend Christopher was more than happy to make several jumps into the water on this very hot summer day. My interest was, of course, in recording a composition of him in exacting sharpness and clarity, stopping the action of the splash that he would make upon entering the pool. Handholding my camera, I first set the shutter speed to 1/500 sec. and then adjusted my aperture until f/8 indicated a correct exposure from the blue water of the swimming pool directly below me.*

17–55mm lens at 55mm, ISO 100, 1/500 sec. at f/8

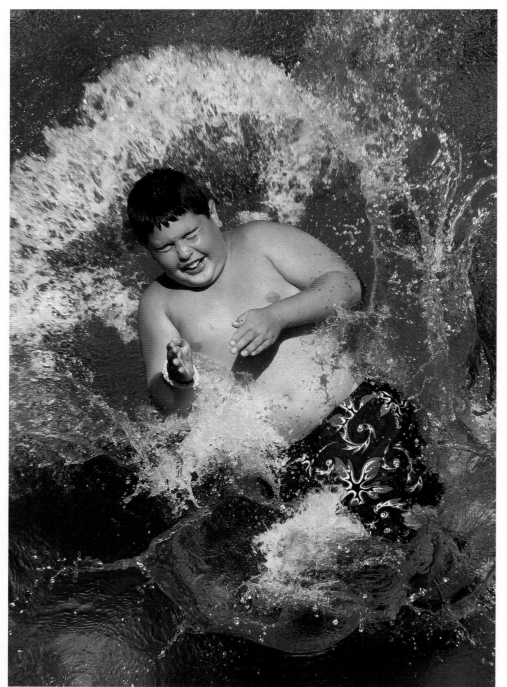

ALTHOUGH MY DAUGHTER *Sophie has never played the violin, she has had plenty of experience in pretending to. Some years ago at a garage sale I purchased this violin solely to use as a prop when I felt the scene lent itself to it. In this case, following the discovery of this wonderful field of wildflowers, I returned home and excitedly shared the news with Sophie. She is also a budding photographer, and the following day we returned—with Sophie, in a freshly washed white dress, and the violin. The skies overhead were bright and overcast, and after Sophie walked out a short distance into the field, I climbed to the third step of a four-foot stepladder and shot down into the field as she made a number of "joy-filled jumps."*

Handholding my camera, I was able to record a number of action-stopping exposures. With the camera set on Aperture Priority mode and the light evenly diffused before me, I was confident that a shutter speed of 1/500 sec. would not only be correct but would record the up-and-down motion of her jumping in exacting sharpness. As evidenced by her hair, she is, indeed, seen clearly in an active state.

70–200mm lens, ISO 100, 1/500 sec. at f/5.6

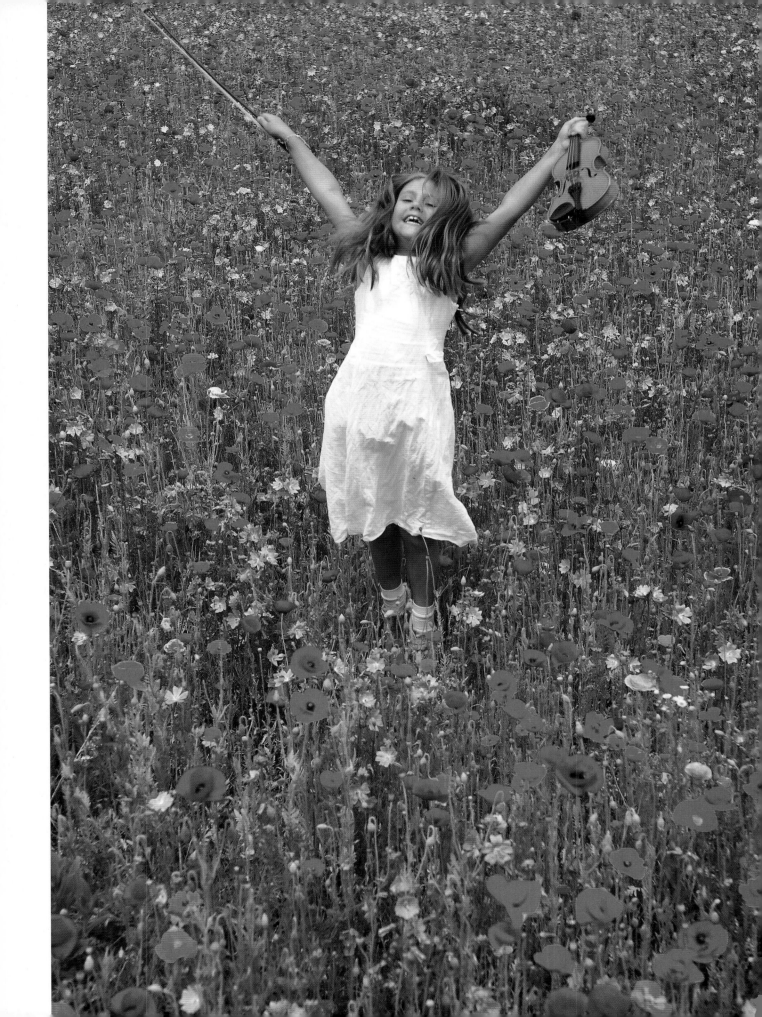

IF NOT FOR THE NEED *to use the porta-potty, I wouldn't have come across this part of the motocross track where the bikers were coming off a large jump hidden behind the pine trees. I thought the porta-potties would be quite a ways from the action of the track, but obviously, I was wrong, as I made this image just ten feet from them. There was plenty of time to set this shot up, too, since each race had as many as twelve to fifteen riders, and each of these riders had to take on this hill—so if I missed the first few, no worries, since there were more to come.*

As the first few did come by, I was able to manually set my focus on an area they all seemed to be flying through. With the camera mounted on a tripod and with my ISO set to 400, I was able to use an aperture of f/13 and still maintain the action-stopping speed of 1/500 sec. I wanted the extra depth of field just in case my focus was off a bit, and when it was all said and done, I ended up with a number of shots like the one you see here. Man is not supposed to fly, but perhaps these motocross riders will make you change your mind.

70–200mm lens, tripod, ISO 400, 1/500 sec. at f/13

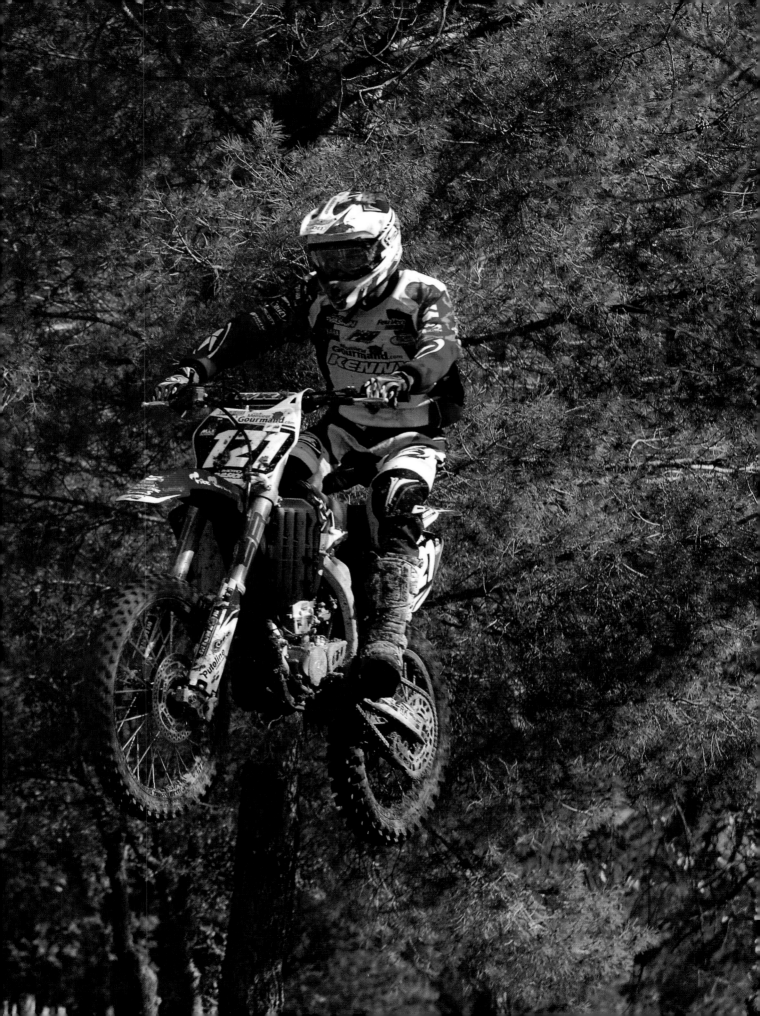

AERIAL PHOTOGRAPHY

Aerial photography is something you do because you are flying from point A to point B on a commercial airliner or you have a friend who has his/her own plane or you're a tourist taking a helicopter tour and so on. I, for one, absolutely love to shoot aerials. Even when I'm on a commercial airliner, I do my best to get a window seat if I think we'll be passing over any areas of interest to me.

Of course, I never check my camera equipment. Wherever I go, my gear goes with me, all packed neatly inside my Lowepro Trekker. Once we're airborne and the seat belt sign has been turned off, I retrieve my bag from the overhead and temporarily place it under the seat in front of me. Depending on what's in store for the upcoming journey, I'll determine if I should use my 17–55mm or 70–200mm lens. And, since the action below me is moving either left to right or right to left, depending on what side of the plane I'm on (God forbid the action is coming toward me!), using a shutter speed of 1/500 sec. is the norm for most aerial photography.

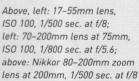

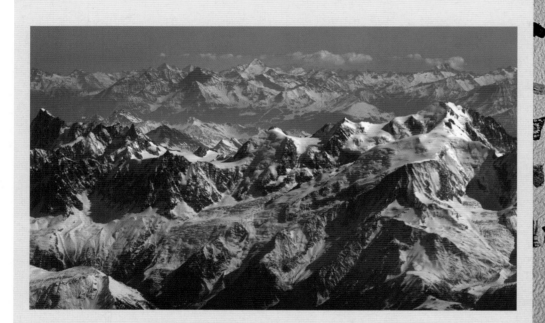

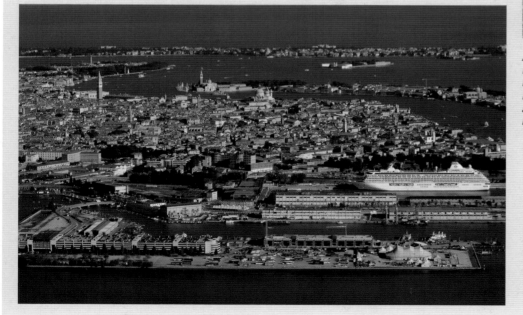

Above, left: 17–55mm lens, ISO 100, 1/500 sec. at f/8; left: 70–200mm lens at 75mm, ISO 100, 1/800 sec. at f/5.6; above: Nikkor 80–200mm zoom lens at 200mm, 1/500 sec. at f/8

I FREQUENTLY FLY from Lyon to Frankfurt. On sunny days, there's just nothing quite like looking out your window, seemingly within arm's reach of the French, German, and Swiss Alps (opposite, top). Shooting from a plane, helicopter, parasail, or an ultralight craft does require the right shutter speed, since you are obviously shooting from a moving object and you do want to record exacting sharpness in the landscape below. Shooting at 1/500 sec. will, in most situations, accomplish this. (The quality of your results will also depend on whether or not the window you're shooting through is scratched.) For this shot at 1/500 sec., I adjusted the aperture until a 1-stop overexposure was indicated. I chose to shoot at a 1-stop overexposure due to the excessive brightness and the abundance of white snow on the mountains. If you were shooting this scene in semi-auto mode, Shutter Priority or Aperture Priority, you would, once again, want to set your autoexposure override to +1, making certain to reset it to 0 when you were done.

It was on another commercial airliner on approach to the airport in Venice that I was able to record the aerial to the left about five minutes before landing. It was a beautiful day, and the late-afternoon sidelight was casting its warm glow across much of the island, in marked contrast to the deep blue sea. Since this scene was evenly lit, without any bright highlights or dark shadows, I felt very comfortable shooting in my second-preferred method of exposure, Aperture Priority. (Although manual exposure mode is still my preferred method of metering, I must confess that Aperture Priority mode has been making up a lot of ground lately, and in all likelihood, it will soon become my first choice when metering most scenes.) I simply adjusted my shutter speed until 1/500 sec. indicated a correct exposure.

Airplanes aren't the only way to get in the air. There are always helicopters. And I love any excuse to shoot down on subjects, oftentimes from much, much higher vantage points. Although I spend a great deal of time walking upon this good ol' earth, my mind is often asking, How would what surrounds me look from overhead? After walking along the very popular Bondi Beach in Sydney, Australia, I felt that the answer to that question would be "Simply amazing!" but then came the even more important questions: Could I get a helicopter rental on a Sunday? And, would a helicopter be allowed to fly above this beach or was it a restricted zone? Two hours later, I was airborne and having the time of my life. With the back passenger door of the helicopter slid wide open and the safety harness secured around my shoulders and waist, I leaned out the open doorway, making a number of exposures while hand-holding my camera (above).

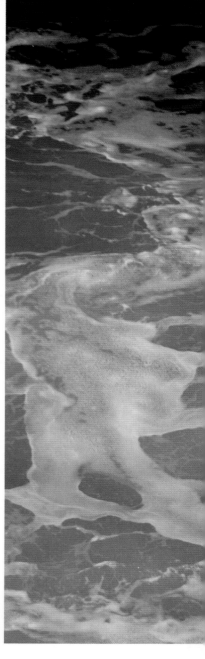

1/1000 SEC.

As noted on page 40, the absence of a 1/1000 sec. shutter speed on my DeJur twin-lens reflex left me feeling a bit cheated. I seldom missed this extra stop, this extra fast shutter speed, yet I can still vividly recall that beautiful autumn Saturday when I had secured a field pass at the local college for that day's football game. Granted, I wasn't going to set the world on fire with shots taken with my twin-lens reflex, but I was determined to get at least one midair-diving-for-the-end-zone shot. Imagine my frustration on processing my three rolls of black-and-white ISO 400 that evening and discovering that my two best jam-packed action shots had just enough subtle blur to be a distraction; it was blur caused by a shutter speed that was just a wee bit too slow—blur that *only* the use of 1/1000 sec. could have eliminated.

I've since learned that it boils down to one thing: If fast action is moving side to side or up and down—and assuming you are truly filling the frame—then 1/1000 sec. is your best choice.

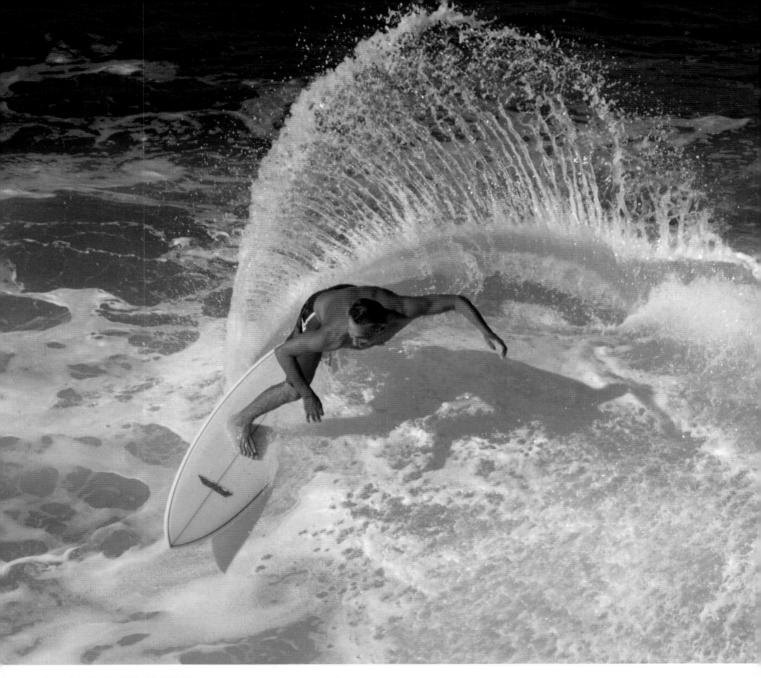

WHILE BUYING ONE OF THOSE *plastic fish-identifier cards at the dive shop across from our hotel on Maui, I overheard a couple of "dudes" talking about the promise of "some big swells coming in on the North Shore tomorrow." I was quick to ask if this meant that the surfers would be out, and they both enthusiastically responded, "Hell, yeah!"*

Rising early the next morning, I found the spot where both big waves and surfers would soon be arriving. After traveling down a somewhat narrow path along a rather steep cliff, I found the perfect shooting spot. Beyond that, it was up to Mother Nature and, of course, some hoped-for surfers. Luckily, my wait wasn't long. Within thirty minutes, several surfers had arrived along with some really large twenty- to thirty-foot waves. It became clear quite quickly that most of the talent pool out there in the beautiful, blue Pacific that morning had been at this surfing thing for some time. There was a kind of fluid poetry to their every move, a rhythm that seldom struck the wrong chord.

With my camera and zoom mounted on a monopod, I set my shutter speed to 1/1000 sec. and adjusted the aperture until f/5.6 indicated a correct exposure from my good friend overhead, Brother Blue Sky. If you're not familiar with the "Sky Brothers," you can read all about them in my book Understanding Exposure, *but suffice it to say, I find the clear blue sky (opposite) a great place to take a meter reading when shooting early-morning or late-afternoon frontlit scenes when those scenes have as much white in them as the waves above sure did. White is a killer when it comes to exposure, as it "reads" far too bright, and often, when one shoots compositions with a lot of white, the end result is an exposure that looks far more gray than white. To avoid this, I almost always will take a reading from the blue sky about thirty degrees above the horizon, since it's "neutral" insofar as it's not too dark or too light.*

Although I was only there for less than an hour, I managed to record a number of really exciting images, with most of the credit going to these guys, who, it seemed, could turn on a dime. One guy was doing a great deal of "cutting," and this image is one of my favorites. With the action below me moving at such a frantic pace, I chose to switch my autofocus mode to AF-Servo, which meant that my Nikon continuously kept my subject in focus as I tracked it inside my viewfinder.

Both photos: Nikkor 200–400mm zoom lens, monopod, ISO 100, 1/1000 sec. at f/5.6

ANOTHER ONE OF MY FAVORITES *from the morning I made the photograph on the previous page, this was one of the few wipeouts that took place that day. This guy took the wipeout in stride. Heck, he even waved good-bye before disappearing momentarily under the weight of this twenty-footer.*

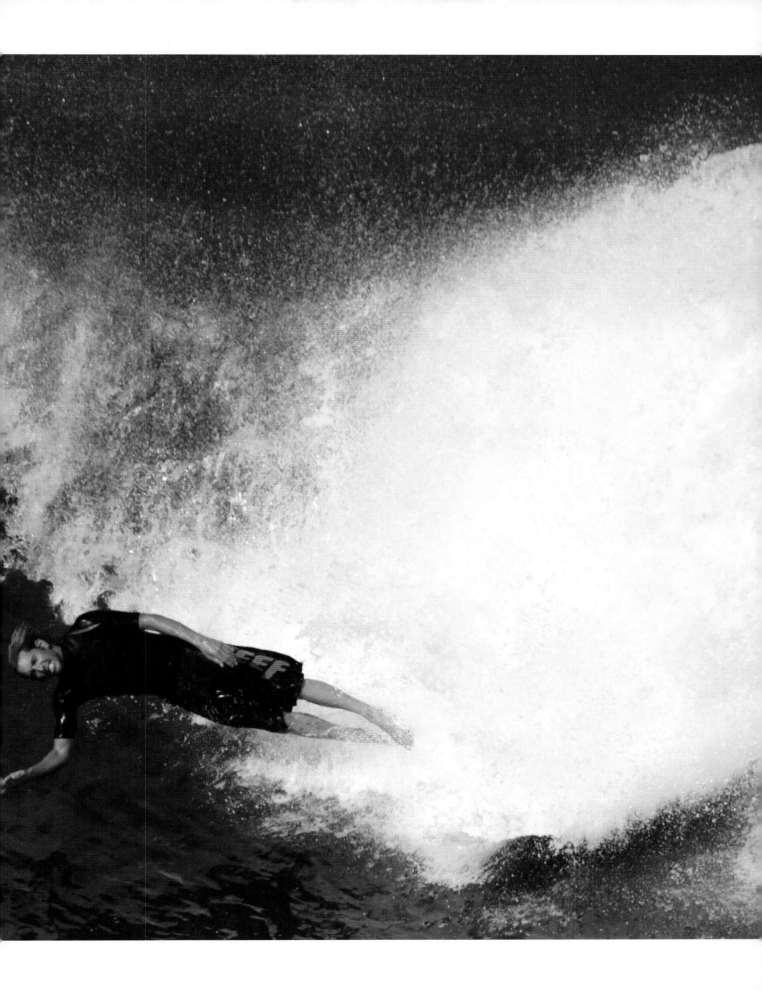

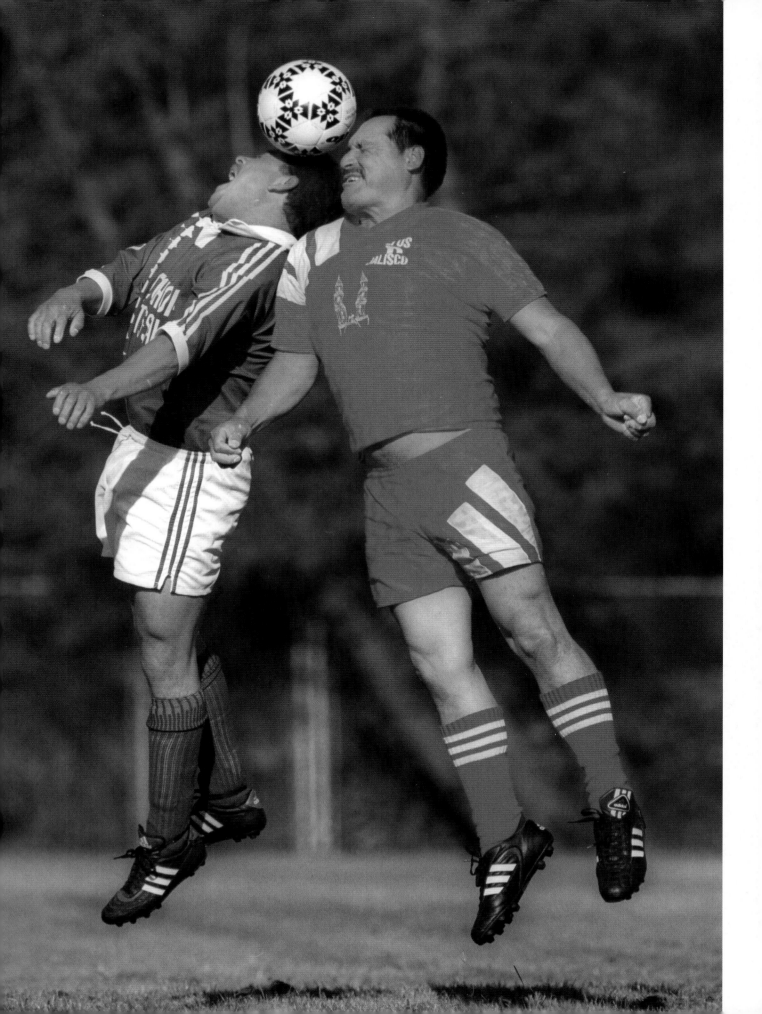

WHEN WE LIVED IN SONOMA, *I became good friends with the guy who did our lawn and pool maintenance. His name was Arnold. He had come up from Mexico along with his two brothers about ten years before, and together, they had built a thriving lawn and pool maintenance business. Each Sunday he and his huge extended family would gather at the local park and play a pretty serious game of soccer. I tagged along on one of those Sundays, and during warm-ups, I was able to fire off a number of exposures, including this one opposite of Arnold's brother and cousin going head-to-head, literally, for the soccer ball.*

One thing stayed with me after this outing: Photographing soccer—or football, basketball, and most sports, for that matter—relies on a great deal of luck and skill. Plus, if you expect to get anything decent, you best keep your eye on the ball. "Follow the ball and shoot!" was a great piece of advice I was given a long time ago by a professional sports photographer. At the time, I had high hopes of becoming a sports photographer. It was 1975, to be exact. Although my dream of shooting sports for a living never materialized (I would always get caught up in the game, and rather than shooting the winning touchdown, I would be on the sidelines, jumping up and down with glee because my team just scored), I still enjoy the occasional challenge of shooting sports, as long as I can walk away from it and just enjoy watching it whenever I want.

300mm lens, monopod, ISO 100, 1/1000 sec. at f/5.6

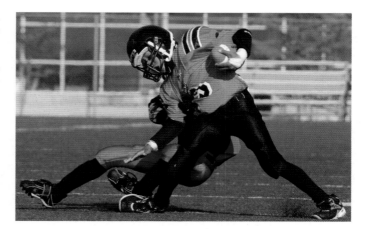

PUMPKINS, BRISK WINDS, *falling leaves, azure blue skies. Sounds like autumn is in the air, and that means football—American-style football, of course. Football is a rough sport, even when kids play it, but I love the game. Heck, I played it as a kid and have the memories of a broken collarbone and wrist to prove it; yet, even today, I'm the first one to show up at the park if a pickup game has been announced.*

My talents at shooting football, however, are one notch above shooting wedding photography, which I learned years ago was not going to be part of my career as a professional photographer. I would much rather endure the intense anxiety and painful withdrawal of trying to survive a day without my Diet Cokes and cigarettes than suffer the excruciating and sometimes painful challenges that wedding photographers often face. For that reason, I was reluctant to agree to shoot pictures of the all-important game that my niece's husband was coaching. Every game is the "all-important" game when it comes to family, right?

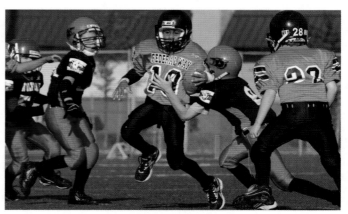

I showed up at the game, and within five minutes, I knew I was in for a long day. Nonetheless, I shot the whole game, 287 pictures to be exact. And the selection to the right shows what you can freeze with 1/1000 sec.—and just how limber the human body is! I used 1/1000 sec. for all three of these images and gladly left the camera in Aperture Priority mode, keeping my eye on the aperture and adjusting it when necessary to make sure my shutter speed was always around 1/1000 sec. I also had my camera mounted on a monopod.

All photos: 80–400mm lens, monopod, ISO 100, 1/1000 sec.

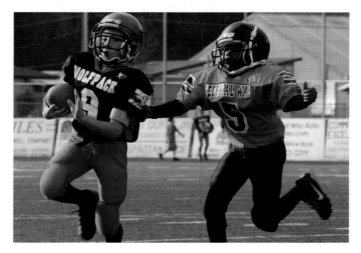

THE ART OF SLOWING DOWN

When it comes to the creative use of shutter speed, I've noticed during my many years of teaching that most photographers, professionals and amateurs alike, seem to migrate more toward recording razor-sharp images of action-filled subjects than toward exploring the "art of possibilities" with much slower shutter speeds. As we just discussed in the previous section, action-stopping images rely on primarily three shutter speeds: 1/250 sec., 1/500 sec., and 1/1000 sec. But let's turn our attention to the opposite end of the shutter speed dial: 1/60 sec. to 1 second. If my hunch is correct, you will soon be finding a lot more reasons to "hang out" with these slower shutter speeds.

In my mind at least, slower shutter speeds offer far more outlets for creativity than faster ones; yet at the same time, slower shutter speeds are incredibly unpredictable. And it is in this unpredictability that, if you can be patient, you will often find the diamond in the rough. Action-filled subjects take on a whole new meaning when deliberately photographed at unusually slow shutter speeds. If you're a purist who still believes in the age-old standard of razor-sharp, everything-in-focus pictures, I don't expect to change your way of thinking, but if you're a photographer who's looking for some fresh approaches to photographing action, subtle or blatant, I strongly recommend that you consider stretching the limits of your slow shutter speeds to the fullest. Try shooting, without benefit of a tripod, for just one hour in your backyard or in the city at speeds of 1/4 sec. or 1 second.

Much of what you'll do when shooting in the slow shutter speed arena will be experimental, but as is often the case, some new and exciting discoveries can be made only in the laboratory. Every shooter who's truly passionate about taking pictures is on a never-ending journey of creative expression and strives to be inventive. Using slow shutter speeds when common sense suggests otherwise has proven to be a successful venture for many shooters. These compositions are often filled with tremendous movement and tension. They convey strong moods and emotions and are anything but boring. You might not be able to identify the sport or activity, but in the midst of all of this blurred activity is an image of great energy.

Fast-action shots normally made with fast shutter speeds take on a different yet very invigorating life when shot at slow speeds. They can resurrect memories perhaps of an earlier exciting time in your life or simply confirm the current excitement you feel. It is our nature to feel invigorated when there's movement under our feet—that feeling that life is exciting, that we are on a journey, that we are within reach of that long-sought-after goal. And of course, everyone at one time or another has experienced boredom or depression, which is simply life without movement. Slow shutter speeds will, without question, reveal a life that is anything but stagnant or boring.

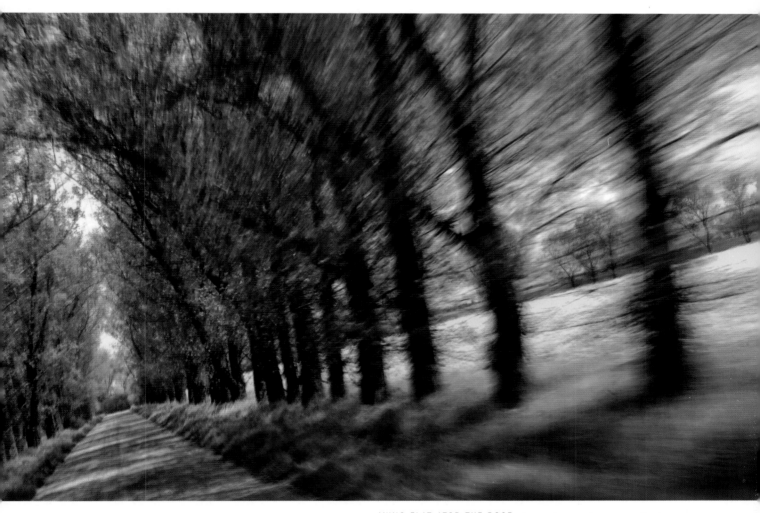

LYING FLAT ATOP THE ROOF *of a moving car down a tree-lined country road, I found myself deliberately shooting at a slow shutter speed, in this case 1/15 sec. I wanted to convey the feeling of flying down the road, as I had seen a crow a few minutes earlier doing just that. Shooting from the safe confines of the passenger seat was out, since the angle was too low to the ground. It was a rough ride, to say the least! I had some apprehension, as the road had its share of potholes, and the car didn't have a roof rack, so hanging on while shooting caused an anxious moment or two. However, my friend Killian drove "slowly," and after making several passes, I had more than enough images to offer up a flying crow's view of this country road in the Czech Republic.*

Nikkor 17–55mm lens, 4-stop ND filter, ISO 100, 1/15 sec. at f/11

MAKING RAIN: ONLY WITH 1/60 SEC.

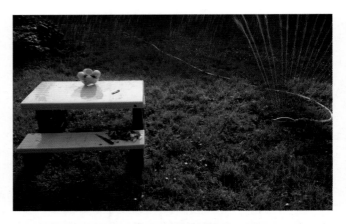

The rain effect is easy to achieve. Whether you choose to set up your "rain" in the early morning or late afternoon, it's important that you (1) use an oscillating sprinkler, since it is best at making realistic falling rain, and (2) place it in an area that has lots of unobstructed low-angled sunshine. Additionally, you *must* face the sun when you shoot, making sure your subjects are backlit (meaning the sun is behind the subject). If your subjects are frontlit or sidelit, you will not record much rain at all, since it's the backlight that creates the contrast, allowing the rain to stand out. Once you have your props, including your subject (some cut flowers or a bowl of cherries, strawberries, or lemons, for example), you are almost ready to produce the look of falling rain, but you must adhere to one simple rule: Use 1/60 sec. You can only make rain using 1/60 sec.

So, the first thing to do is set your shutter speed to 1/60 sec. and make sure to use an ISO of 100 or 200. Now all that remains is to get the correct meter reading, and the best way to do this is to move in close so that your backlit subject (flowers or fruits) fills most of the frame *before* turning on the water. Then, you simply adjust your aperture until the light meter indicates a correct exposure. Next, move back a bit and frame up your overall composition, and with the camera on tripod and your exposure set, fire up the sprinkler. Note if the falling "rain" is cascading down across the entire flower or fruit area, and if it's not, then move the flowers or pieces of fruit so that they are being completely covered by the falling rain. Once everything is perfect, simply start firing away when the sweeping arc of the oscillating sprinkler begins to fall just behind and then onto the flowers.

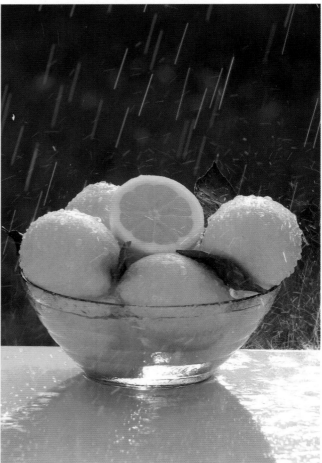

HERE'S MY SETUP *in the top photo on the facing page, and the result is at right. What happens if you try and shoot this effect at a faster or slower shutter speed? The results won't look like rain. Anything slower or faster just doesn't look believable as rain. As you can see in the lower image on the facing page, at the faster shutter speed of 1/125 sec., the raindrops are much too short—plus, the shorter streaks of rain don't feel quite as refreshing. At slower shutter speeds than 1/60 sec., the rain streaks become much too long and lose their luster. In addition, when it comes to lenses, I almost always choose the 200mm or 300mm focal length for rain shots, not so much because these focal lengths have an inherent shallow depth of field, but because they enable me to record pleasing compositions without getting wet.*

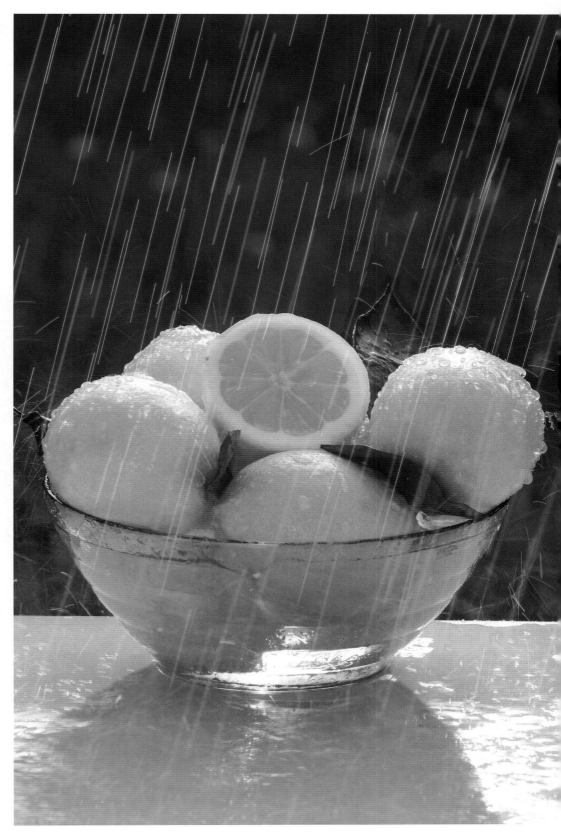

BACKLIGHT WITHOUT SILHOUETTES

One of the more common questions I get from students deals with the subject of backlit portraits: "Since the sun is behind the person whose portrait I want to take, how do I avoid recording a silhouette and render detail of that person's face and character?" Experienced photographers use a reflector most of the time in these situations. A reflector is nothing more than a white, gold, or silver piece of fabric that has been attached to a pliable ring that allows for a quick and easy setup. A reflector that's ten inches in diameter while stored in its zippered pouch opens up to a thirty-inch reflector (that weighs almost nothing, by the way).

When you aim a reflector into the sun's light, it acts in many ways like a mirror, bouncing this light right back toward the sun. However, it's not the sun you want to reflect light back into but the subject that's facing you. So, in effect, it's like having *two* suns: one that backlights your subject and one that "frontlights" your subject. Studio photographers have been using this "two sun" approach for years, so why not you?

There is, of course, one other concern when using reflectors: Who is in charge of holding the reflector? If you don't have four hands, then this is a good time to bring someone along and have him or her be your grip (the person whose job it is to hold the reflector). Once you and your assistant have reflected the sunlight back onto the subject, it is equally important that you move in close with your camera to set an exposure *for this light that is now hitting the subject.* Even if you are so close that you cannot get your subject in focus, don't worry; you are only interested in recording an exposure.

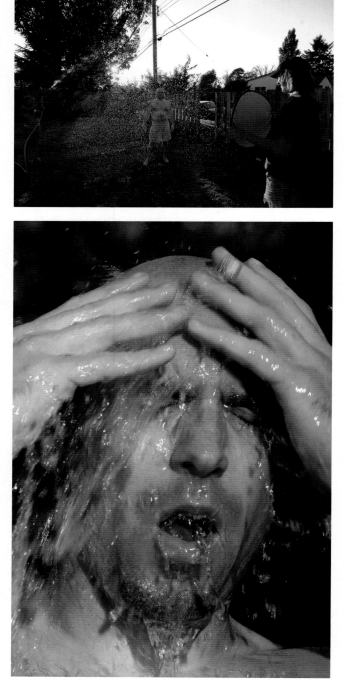

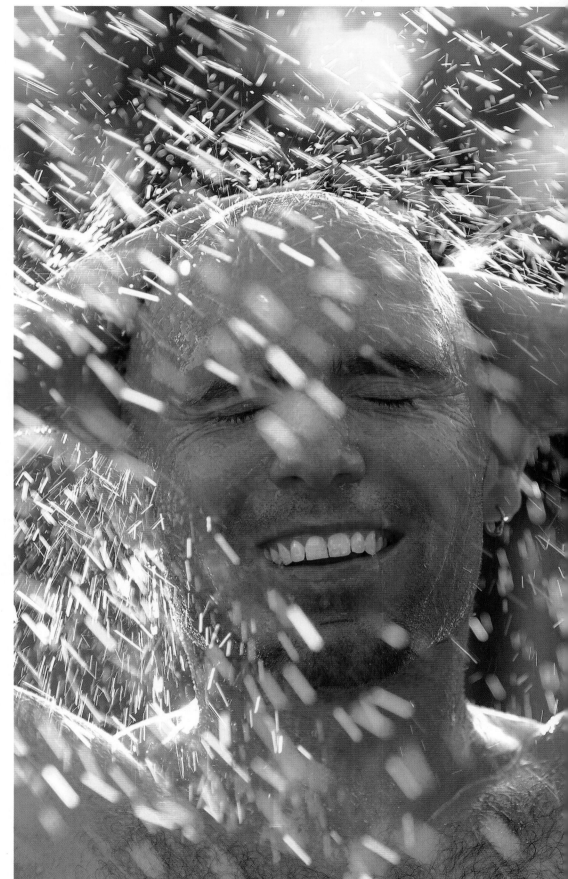

WHEN COMBINED with the right rain-making shutter speed of 1/60 sec., a really fun backlit portrait awaits you—if you can find a willing model and you have access to a garden hose. You can make the idea of cooling off on a hot summer's day even more appealing when you combine it with the effect of cooling drops of "summer rain." For the purposes of comparison, the bottom image on the facing page of my niece's husband, Jason, shows him cooling off while frontlit by the warm glow of late-afternoon sun. The much stronger example in my mind shows Jason backlit by the same sun (right).

In this case, because Jason is obviously not transparent (unlike water, which is), I felt it necessary to fill his face with reflected sunlight. With the aid of my son, Justin, and daughter Chloë, I was able to do just that: Justin held the reflector and Chloë provided the "rain" (opposite, top). All that remained was to fill the frame with just Jason's face, set my shutter speed to 1/60 sec., and adjust my aperture until f/11 indicated the correct exposure.

Nikon D2X, 70–200mm lens at 200mm, 1/60 sec. at f/11

SLOW
SPEEDS

PANNING: 1/30, 1/15, 1/8, AND 1/4 SEC.

Our journey through the land of creative shutter speeds must include a visit with, to quote many of my students, "a most frustrating, yet really rewarding technique" called *panning*. When you pan any moving subject, you will almost always be shooting from a point of view that is directly parallel to your subject. When your moving subject enters the frame from the left or right, you simply follow it with the camera, moving in that same direction while depressing the shutter release button. This ensures that your moving subject remains relatively "stationary" (in that same spot in your viewfinder) and in fairly sharp focus, while all of the stationary objects surrounding it record as either horizontal or vertical streaks. (Normally, when one pans, the subjects are moving right to left or left to right, but you should expand your horizons and consider panning vertical motion, too—for example, kids on pogo sticks or seesaws, the up-and-down "free-fall" rides at amusement parks).

To pan effectively, you'll want to use a shutter speed of at least 1/30 sec. But again, I'm all about experimentation, and if you're shooting digitally (i.e., with no film costs), consider panning at even slower shutter speeds, such as 1/15, 1/8, or even 1/4 sec. When you pan any subject, keep in mind that you *must have an appropriate background* in order to be successful. And what, exactly, is an appropriate background? Something colorful. Since backgrounds are rendered as blurred streaks of color and tone when you pan, you'll find that the more busy and colorful the background, the better the panned subject will look in front of it. If you were to paint colored horizontal streaks onto a canvas, streaks of the same color would look like nothing more than a solid color (with no evidence of the streaking). But if you were to use several colors, you would be able to distinguish the streaks.

In much the same way, panning when your subject is a jogger against a solid blue wall will show little, if any, evidence of the panning technique because of the lack of tonal shift or contrast in the background. However, if that same wall is covered with posters or graffiti, it will provide an electrifying background when panned. Simply put, the greater the color and contrast of the background, the more exciting the panned image will be. So, in addition to concentrating on the many motion-filled panning opportunities, make it a point to shoot those opportunities against colorful backgrounds.

THE ADDED ADVANTAGE OF DIGITAL

For those of you shooting with a digital camera, you'll soon be counting your blessings as you try your hand at panning. It is a challenging exercise in getting it right, and needless to say, a lot of shots are wasted until you get *that one*. So, this technique can be a nightmare for many photographers who still shoot film, and I know of at least one former film shooter who found this panning technique to be a blessing in disguise: A student in one of my online courses informed me that "thanks to the lesson on panning," her husband went out and bought her a digital SLR after he noticed how much film from that one lesson went into the trash. Since she had six more weeks of lessons to go, he reasoned that she would probably be throwing away even more film and "surely, the cost of all that film would more than pay for a new digital SLR."

And, wouldn't you know it, when this story got out to the other class members, several of whom were also still shooting film, they made a point to place their garbage cans right in front of their respective spouses and then do the "moan and groan": "If only I had a digital camera. . . ." By the time the class ended, there was not one film shooter left in the bunch!

TIMES SQUARE IN NEW YORK CITY *is one of the richer locations for creating successful panning shots, owing to the nonstop hustle and bustle of traffic in the street and the pedestrians on the sidewalks. Additionally, there is no shortage of backgrounds, thanks to the numerous neon signs and billboards suspended above the shops and restaurants. Handholding my camera, I simply moved left to right and at a diagonal as one of many stretch limos came driving down Broadway over the course of an hour. Since I was focusing solely on this limo and following it as it moved (plus shooting at a slow shutter speed) I recorded a relatively sharp vehicle against some very colorful, blurry, streaky background signage. A truly high-energy image that conveys the sights and sounds of Times Square was the result.*

My reasoning for shooting on the diagonal was really quite simple: A diagonal line imparts a sense of movement and speed, even when it is a still diagonal—for example, a ladder leaning against a house. And since I was panning in this case, I felt the result would be an even bigger "rush," a greater sense of movement and speed, when shot as a diagonal composition.

17–55mm lens, ISO 100, 1/15 sec. at f/8

OPPORTUNITIES TO PAN *really are everywhere, but when it comes to finding an abundance of these photo ops, the city really is king. From New York to San Francisco, London to Rome, Tokyo to Singapore, cities are on the move, by day or by night. And when you throw in some rain, the once monochromatic sidewalk of pedestrians is transformed into a flowing river of colorful umbrellas. Here, I handheld my camera, set it to 1/30 sec., and adjusted my aperture until a correct exposure was indicated at f/11. I then aimed at the sidewalk directly across from me, replete with colorful newspaper stands, and followed this hurried group of pedestrians. The overall combination of color and movement creates an energized image whose volume is extra loud, an image that is anything but quiet.*

70–200mm lens, ISO 100, 1/30 sec. at f/11

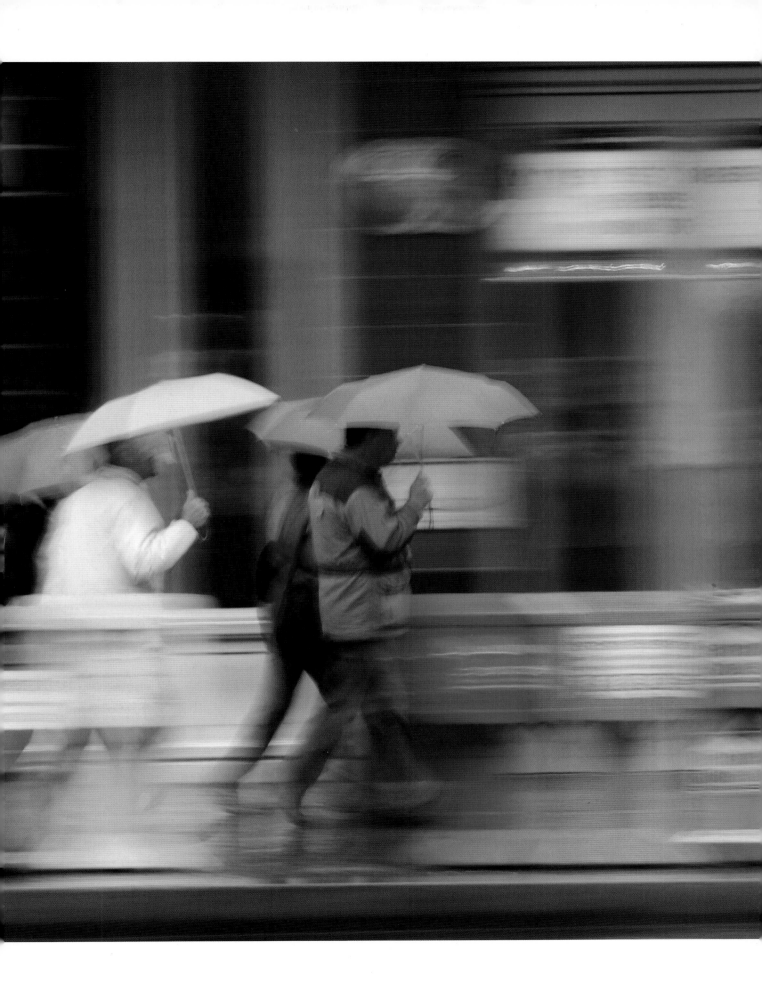

I AM NOT A PROFESSIONAL WILDLIFE PHOTOGRAPHER. *I also learned early in my career that I just don't have the patience to wait for the bald eagle perched in the nearby cottonwood tree along the Skagit River in Washington State to come swooping down and grab a clawful of salmon. Perhaps I suffer from ADD, but something else will forever grab my attention while waiting for a shot like that—and when it comes to wildlife photography, you can't afford to miss such a shot (which I did because a nearby spiderweb distracted me).*

However, when I came upon a flock of restless flamingos at the Singapore Zoo, I had no trouble becoming a wildlife photographer. From the relaxing confines of a sundeck overlooking the flamingos below, I was able to shoot a number of compositions that showcased them as they flew over. To do this, I used a shutter speed normally reserved for shooting waterfalls. Handholding my camera and using my polarizing filter, I was able to record an exposure of 1/4 sec. at f/22. As I fired the shutter release, I also moved in the same right-to-left direction as the flying flamingo. This creative rendition of the bird in flight is a direct result of the use of 1/4 sec. Would it really be that interesting if I had shot at a blazingly fast 1/1000 sec.? Chances are I would have had another run-of-the-mill, flamingo-in-flight shot.

70–200mm lens, ISO 100, 1/4 sec. at f/22

IN A MANNER TYPICAL *of the Peterson family, we decided at the last minute to head up to the French Alps, Chamonix to be exact, for several days of skiing. We had yet to ski this winter and although the calendar said one week until Easter, the clouds above the French Alps were still pouring down snow as if it were Christmas.*

Although our first morning on the slopes was met with sunshine, an azure blue sky, and mild temperatures, it got progressively cloudy as the day wore on, until finally, the snow began to fall. I had already removed my skis, thinking it was time to assume the role as the family photographer once again and get some shots of the girls and my wife, Kathy, making what proved to be their final run down the mountain. They were hopeful of getting some simple snapshots; however, and much to the chagrin of my family, I chose to shoot some "fine art" shots. (In retrospect, I should have taken the snapshots earlier that morning, but hey, I wanted to ski, too.)

My reasoning in going the fine art route was simple: The light was all but gone, and we were approaching a whiteout due to the falling snow. With not much light and impending whiteout conditions, what more could I do? So, with my camera in my cold but steady hands, I zeroed in on my daughter Chloë, who was heading right for me, and just as she veered to my left, I fired off several frames at the correct exposure of 1/4 sec., while also moving the camera in the same right-to-left direction she was traveling.

70–200mm lens, ISO 100, 1/4 sec.

SNOW TIP

Here's an exposure tip for all you snow lovers out there: If you're shooting in the snow in any of the automatic modes (Aperture Priority, Shutter Priority, Program, and so on), set your autoexposure overrides to +1 if it's a cloudy day and +2 if it's a sunny day. This will prevent the often-seen underexposed, gray images of snow.

Your camera's light meter thinks the world is a neutral gray color, and it "reads" everything based on that. But, the last place in the world where you will find any neutral gray is on the ski slopes. When the meter is "hit" with all of that white, whether it's a cloudy day or a sunny one, it reacts in a "hostile" manner and serves up exposures that are either 1 or 2 stops underexposed. In other words, it can't stand to see anything that bright, and it will do its best to turn the snow into the neutral gray tone it's familiar with.

So again, the solution for you autoexposure junkies is to simply set the autoexposure override as described above, and if you're one of my manual exposure heroes, you don't need any advice.

AS YOU MAY HAVE GATHERED *by now, I'm a big fan of shooting down on subjects, and when you live three stories above the street, every day seems to present something new to photograph. This past winter, we had one fairly good snowfall with blizzardlike conditions, and it wasn't long before I saw someone caught out in it. I was quick to raise the camera to my eye, and with my exposure already set to 1/8 sec., I decided to try my hand at panning on a diagonal in the same downward direction as the falling snow. I got lucky with one of the shots I made that day. No doubt, it's an image that conveys the harshness of a winter storm, and what really makes this message loud and clear are the many diagonal lines of falling snow. Unlike the horizontal or vertical line, the diagonal line is filled with movement and speed. It never rests, it never tires, it is constantly on the move, and considering that we are looking at snowfall, it feels quite brutal and cold.*

Nikkor 17–55mm lens, ISO 100, 1/8 sec. at f/16

HAVE YOU EVER BEEN CHASED *by a ferocious dog while riding your bike or scooter? Are you one of those dog owners whose dog chases after bikes and scooters? While shooting one morning on the island of Santorini, I was quickly adopted by several wild dogs—an easy thing to have happen when you offer them food. Shortly after shooting a sunrise over several of the white- and blue-domed painted churches, I found myself sitting at a small café situated on the square—along with "my dogs." It was a quiet time of day, but within thirty minutes, the square came alive with numerous scooter riders. Without fail, at the sound of each oncoming scooter, the dogs would take off running, apparently thrilled at the prospect of nipping the rider's heels. Try as I might to get my dogs to stop this behavior, they made it clear, complete with their snarls, that they were committed to this game and we had no chance of stopping it.*

In the tradition of "if you can't beat 'em, join 'em," I decided to try some panning shots as the dogs chased every scooter. After about thirty minutes, the square was quiet once again, and I learned from the owner of the café that most of the scooter riders were simply fishermen heading off to work who were quite accustomed to being chased by these dogs. Seems the dogs are forever adopting new owners with the arrival of every plane or boatload of tourists, and this day just happened to be the day I got chosen. Although I remained on Santorini for another three days, I never saw my dogs again.

17–55mm lens, ISO 100, 1/15 sec. at f/16

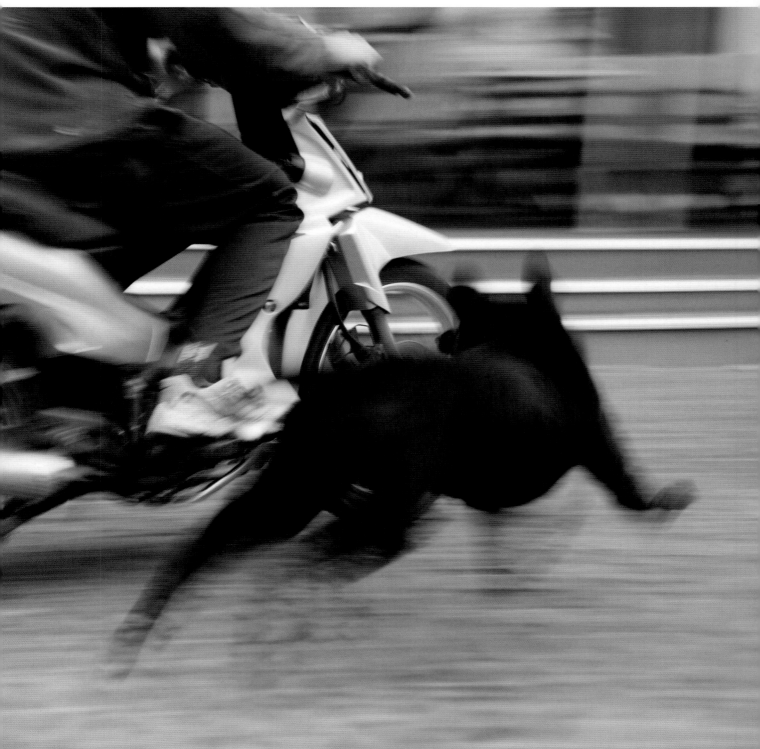

WHILE ON ASSIGNMENT *in the shipyards of Charlotte, North Carolina, I had numerous opportunities to try my hand at panning. It proved to be quite a place of nonstop action as three containerships arrived, all within four hours. Those mighty cranes were hard at work, loading and unloading container after container. Of particular note with the shot to the left is that the panning motion was not horizontal. The container was being lowered from the ship, so I panned moving downward, following its slow path to the ground below.*

NOW HERE IS AN EXERCISE that I know can be fun, and you can do it without ever leaving your home. Spend an hour with your hand! While holding the camera with one hand, photograph your other hand at various slow shutter speeds such as 1/15 or 1/8 sec., and voilà! You will be surprised at the results.

How about your hand opening up the fridge? Your hand getting a beer? Your hand serving some cake or pie? Your hand playing air hockey? Your hand pounding a nail? Your hand washing windows? Your hand painting the house? The possibilities are endless. When you're done thinking about this exercise, if nothing else, you will at least be well versed in just how much activity your hands go through. In this example, after choosing some cherry tomatoes at the outdoor market, I followed my hand (panning once again) as it flew across the display of other vegetables complete with money to pay the vendor.

12–24mm lens, ISO 100, 1/15 sec. at f/16

IMPLYING MOTION—WITH A TRIPOD

When the camera remains stationary—usually on a firm support such as a tripod—and there are moving subjects within the composition, the photographer is presented with the opportunity to *imply motion*. The resulting image will show the moving subject as a blur, while stationary objects in the composition are recorded in sharp detail. The list of potential moving subjects is long: Waterfalls, streams, crashing surf, planes, trains, automobiles, pedestrians, and joggers are but a few of the more obvious ones. Some of the not so obvious include a hammer striking a nail, toast popping out of the toaster, hands knitting a sweater, coffee being poured from the pot, a ceiling fan, a merry-go-round, a seesaw, a dog shaking itself dry after a dip in the lake, wind-blown hair, and even the wind blowing through a field of wildflowers.

Choosing the right shutter speed for many of these motion-filled opportunities is, oftentimes, a process of trial and error. It is here that, once again, the digital shooters have the advantage, since they can view instantly the results of the right or wrong choice in shutter speed on their LCD panel. Additionally, there are no film costs involved, so this photographic trial and error costs nothing.

There are certainly some general guidelines to follow, and if nothing else, they can prove to be good starting points for many of the motion-filled opportunities that abound. For example, a shutter speed of 1/2 sec. will definitely produce the cotton candy effect in waterfalls and streams. A shutter speed of 1/4 sec. will make the hands that knit a sweater appear as if they're moving at a very high rate of speed. A 30 mph wind moving through a stand of fall-colored maple trees, coupled with a 1-second shutter speed can render a composition of stark and sharply focused trunks and branches contrasted with wispy, wind-driven overlapping leaves.

THE VALENSOLE PLAIN in France continues to be one of my favorite shooting locations in all of Europe. In late June and early July, the air is filled with the scent of hundreds of acres of lavender and the sound of buzzing bees, bees that are far more interested in the flower's scent than they ever might be interested in you, which is a relief for anyone who is allergic to bees. On most any afternoon, the hot winds of the Valensole Plain increase, and thus begins the dance with each and every row of lavender, a dance of long stems swinging left to right, right to left in the hot blowing wind like a gospel revival with arms and clapping hands extended high.

With my camera on a tripod and at flower level, I waited momentarily for the wind to moderate a bit and fired off the first image (top) at f/11 and 1/250 sec. Next, I reached into my filter wallet and first placed a 4-stop neutral-density (ND) filter on my lens, thereby cutting the light value down by 4 stops; then, I added my Nikkor polarizing filter, cutting down the light value by another 2 stops. I readjusted my exposure for this 6-stop reduction in light, which meant I had an exposure of f/11 at 1/4 sec., but I still wanted to set a longer exposure, so I stopped the lens down further to f/22 (2 more stops). My final exposure was f/22 for 1 second (bottom).

Opposite, top: 12–24mm lens, tripod, 1/250 sec. at f/11; opposite, bottom: 12–24mm lens, tripod, 1 second at f/22

BORN IN IOWA, *Carl Magee, a lawyer and publisher, was, according to San Miguel County Judge David Leahy in 1920, a "lying, un-American political harlot, fatheaded imbecile remittance man, dirty cowardly reprobate, wicked, wanton, false, malicious dishonest, corrupt, unscrupulous, and worse than the assassin of President McKinley." The judge was responding to an article Magee had written in the Albuquerque Journal, which Magee also owned, in which he called San Miguel County's government the worst in the United States. Five years later, these two guys ran into each other in a hotel, and according to the El Paso Times, a wild fistfight ensued. Magee pulled out a pistol, trying to shoot Judge Leahy but killing innocent bystander John B. Lassater instead.*

Magee was acquitted of manslaughter, but if he had been found guilty and been incarcerated, all of us just might have missed the joy of feeding money into a parking meter, since it was Carl Magee who is credited with inventing and patenting the first parking meter, which was later installed on the streets of Oklahoma City on July 16, 1935.

To get this shot, I used a tripod-mounted camera and 70–200mm lens. With my aperture set to f/16, along with the polarizing filter, I was able to record a correct exposure at 1/30 sec., which proved to be just slow enough to record the blurred motion and graphic color of the many large trucks I photographed that afternoon in Tampa Bay, Florida.

70–200mm lens, ISO 100, 1/30 sec. at f/16

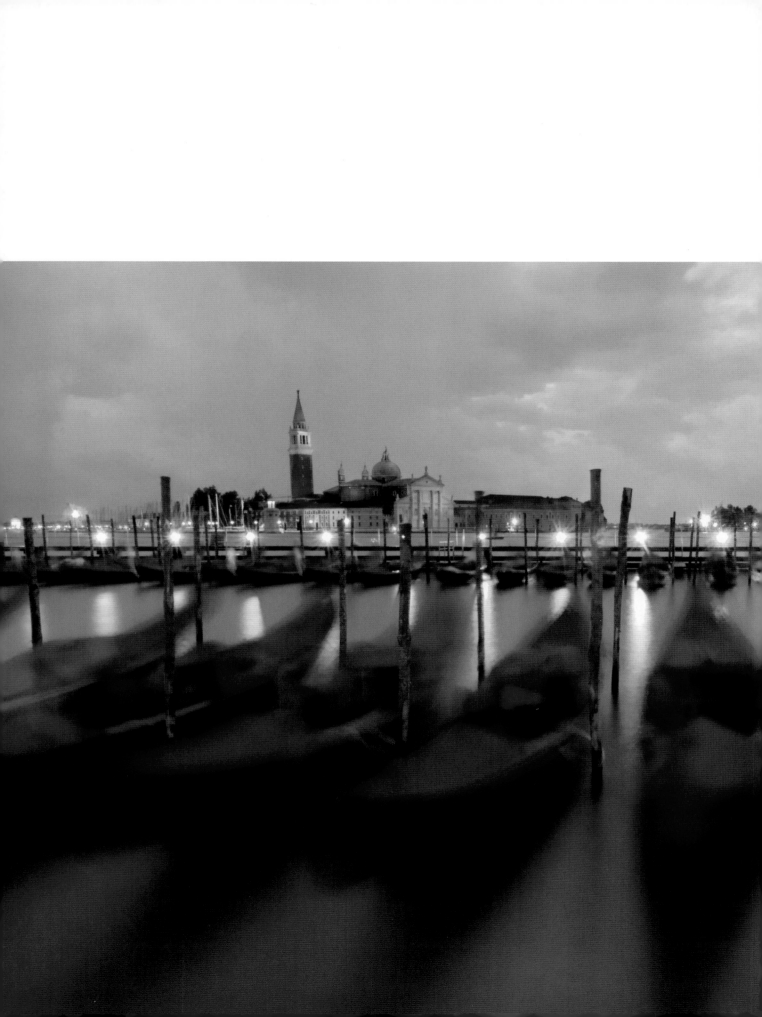

VENICE, ITALY, *continues to be one of the most visited cities in all of Europe, and the gondolas are, of course, one of the bigger attractions. Seldom, however, do I run into other photographers who, like me, are out before sunrise shooting the many docked gondolas near Piazza San Marco. As difficult as it is for some, getting up with the roosters does have its rewards, not the least of which is having much of the world all to yourself. Of course, at this hour you will need a tripod, since in all likelihood, whatever you choose to shoot will require really slow shutter speeds.*

As you can see, the first exposure (below) doesn't record a lot of movement, and this has much to do with the exposure time of 1/8 sec. at f/8. However, there was a large ferry coming into the scene from the left, which I knew would kick up quite a wake, and shortly after it passed, these same gondolas were dancing atop the water's surface. So, I changed to a much longer exposure time, again with the addition of my polarizing filter (a 2-stop reduction of light) and by stopping the lens down further (left).

In both exposures, I initially took my reading off of the dusky blue morning sky by simply aiming the camera up above the gondolas. In the first example, that meant that with my aperture set to f/8, I adjusted my shutter speed until 1/8 sec. indicated a correct exposure; in the second exposure with the polarizing filter in place, I pointed my camera to the sky, stopped the lens down to f/22, and then adjusted the shutter speed dial until 4 seconds indicated a correct exposure. The result: We see and hear the "ghosts" of gondola operators and riders of years gone by.

Below: 1/8 sec. at f/8; left: 4 seconds at f/22

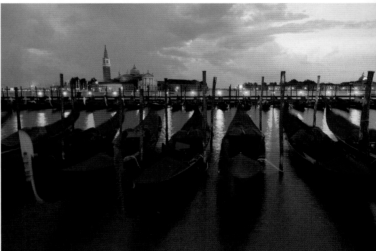

RETURNING HOME FROM A WORKSHOP, *I was greeted at the front door by my two daughters and wife, all of whom had large, precocious grins on their faces. The grins were soon explained when, a few minutes later, I was greeted by the new member of the family, Cosmo. Although I thought we had all decided a few weeks earlier that getting a dog at this time was not a good idea and that when and if we did, we would get a dog and not a "toy," Cosmo had soon stolen all our hearts.*

Cosmo enjoys being out on the terrace, and one such morning, the winds were really strong, so every so often his ears appeared to be standing straight up, due to the wind coming up from the streets below. I was able to shoot several slow exposures with my Leica D-LUX 3, quite possibly the best digital point-and-shoot currently on the market. With the ISO set at 100 and the camera set in Aperture Priority mode, I was able to fire off several frames at f/5.6 and 1/30 sec., which was perfect, as this exposure registered some subtle blurring of wind-whipped ears, rendering a portrait of Cosmo the flying Pekingese!

Leica D-LUX 3, ISO 100, 1/30 sec. at f/5.6

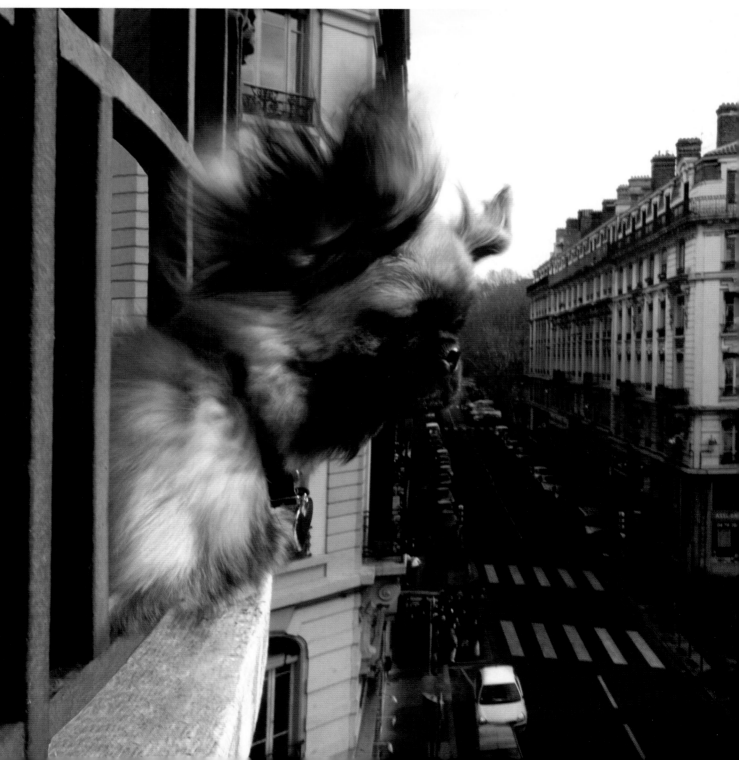

FOR YEARS, STUDIO PHOTOGRAPHERS *have used ordinary fans to bring some "movement" to their fashion work. It's a really simply idea, too, and definitely an effective one if you wish to record an image of sensuality and/or playfulness. The key to making a shot like this work is to, once again, use the right shutter speed. It's also important to ask the question "Do you want to freeze the action of the blowing wind in crisp sharp detail or showcase the windy conditions as a subtle soft blur?" In this simple yet effective composi- tion of my wife, I chose to shoot at an action-stopping shutter speed of 1/250 sec. Using one monolight placed inside a softbox off to her left (my right), I was able to determine with my Sekonic Flash Meter that an aperture of f/11 was the correct exposure based on the five-foot distance of the flash to her face and based on my choice in using ISO 100. With the fan only three feet away to her right (my left), her long blonde hair was quickly blowing as if caught in a 15 mph wind gust. Handholding my camera, I took a number of shots as the "wind" blew, and as you can see here, the blowing hair has been captured in exacting sharpness across her face.*

70–200mm lens, ISO 100, 1/250 sec. at f/11

"PAINTING" WITH SHUTTER SPEED

Until recently, the "rule" of photography was to keep the horizon line straight and, above all else, make sure it's in focus. It was also unthinkable for a photographer to deliberately handhold the camera while using a very slow shutter speed. Those who did venture out of this "norm" were often scoffed at because the resulting images were, of course, blurry and out of focus, and on more than one occasion, the photographer was asked, "Were you drunk when you took that shot?"

Fortunately, times have changed, and the idea of "painting with a slow shutter speed" has been embraced. But, unlike panning, which is already challenging enough, painting with a slow shutter speed is a real hit-or-miss affair. When everything does come together, however, it is truly rewarding. (Have you priced abstract art lately? Doing it yourself is not only cheaper, but since you "painted" it yourself, it's also that much more rewarding.)

Painting with shutter speed is a simple technique, really. You simply set a correct exposure that will allow you to use a shutter speed of 1/4 or 1/2 sec., and at the moment you press the shutter release, you twirl, arch, jiggle, or jerk the camera in an up-and-down or side-to-side or round-and-round motion. The challenge is in finding the right subject to paint. Just as Monet discovered with his brush and canvas, flower gardens continue to be the number one choice of photographers for painting with shutter speed, but don't overlook other compositional patterns as well, such as harbors, fruit and vegetable markets, and even the crowd in the stands at an NFL football game. Also, consider painting with shutter speed in low light, where shutter speeds can range from 2 to 8 seconds. The difference here is that your movements are slower than the quick and hurried movements just mentioned, and the resulting effect can mirror the work of an artist who uses a palette knife, as the exposure time builds up one layer upon another. Presto! An instant abstract painting.

NOT MUCH IS REQUIRED *to create some truly exciting "abstract paintings" with your camera other than a slow shutter speed and the willingness to perhaps look foolish in the presence of others. When you are defying all the "laws" of photography, strangers stop momentarily, as they find it odd to see you jiggling, spinning, jerking, or turning your camera while pressing the shutter release. They can't for the life of themselves understand what on earth you could possibly be so happy about. You might even, perhaps, give the impression that you suffer from a nerve disorder, which would no doubt account for why you can't hold the camera steady. But do you really care?*

In a large wooden planter right in front of Ivar's Seafood Restaurant on Seattle's Pier 54, a lone sumac tree was showing evidence that autumn had arrived. The first exposure of f/8 for 1/60 sec. resulted in just another rather mundane shot of fall color, but when I set the exposure to a much slower shutter speed—f/22 for 1/8 sec.—and then fired the shutter release a number of times while making circular motions with the camera, the results were anything but. The swaths of color are reminiscent of the work of an artist applying paint with a palette knife.

Opposite, top: Nikkor 12–24mm lens, ISO 100, 1/60 sec. at f/8; opposite, bottom: Nikkor 12–24mm lens, ISO 100, 1/8 sec. at f/22

FOLLOWING A HARSH and cold winter, this roadside flower bed in the heart of Lyon, France, provided a welcome reminder that spring had arrived. Standing over a portion of the flower bed and shooting down with my camera and 12–24mm lens revealed a most interesting and energy-filled composition that was reminiscent of those times I went to the county fair in my youth, where I would gladly pay the man 25 cents for a white piece of paper on which I would squirt various colored paints and then have it spun around for several seconds to reveal a kaleidoscope of colors.

So how did I do it? It's a rather simple technique, but you'll want to call on your wide-angle zooms first and foremost— and your polarizing filter and/or a 3- or 4-stop neutral-density filter. You are calling up these two filters primarily to decrease the intensity of the light, thus allowing you to use slower-than-normal shutter speeds while still maintaining a correct exposure. And so, with my 12–24mm lens set to a focal length of 12mm and fitted with a 4-stop ND filter, I was able to set a correct exposure of f/11 for 1/4 sec., and as I pressed the shutter release, I did the following: I rotated the camera in a right-to-left circular motion, as if drawing a circle, and at the same time, with my left hand, I zoomed the lens from 12mm to 24mm (opposite, top). And keep in mind that all of this took place in 1/4 sec., so you are right to assume that you must be quite fast in turning the camera in that circular motion and zooming at the same time.

In comparison, with the next shot I was able to slow down a bit as I repeated the same moves, because I had changed my exposure from f/11 for 1/4 sec. to f/22 for 1 second (opposite, bottom). Of course, the choice is yours, but clearly, the spiral effect that results leaves a bit more definition in the flowers at 1/4 sec. than at 1 second.

Opposite, top: 12–24mm lens at 12mm, ISO 100, 1/4 sec. at f/11; opposite, bottom: 12–24mm lens, ISO 100, 1 second at f/22

FOR SOME PEOPLE, walls and doorways covered with graffiti and posters are unsightly, but personally, I have found them to be great fields of photographic potential that I harvest often with my macro lens. It was only recently, however, that I discovered they are also a great "painting" resource. Again with my camera and 12–24mm lens equipped with a 4-stop ND filter, I was soon turning and zooming at the same time, moving from one wall or door to the next, shooting with such careless abandon and experiencing, once again, that feeling of newness that often accompanies every photographer's first few days or weeks behind the camera (opposite, top).

After just turning the camera, I went to work on another wall of "art," and this time, rather than spinning, I simply moved the camera in a slow upward direction while zooming the lens quickly in and out, in and out at the same time. Note in this exposure (opposite, bottom) the somewhat stair-stepped effect, a layered palette-knife-painting effect. This was the result of moving up and zooming in and out at the same time rapidly over the course of my 2-second exposure.

This same slow upward motion, along with repeatedly zooming the lens rapidly, was also behind the very painterly effect of the flowers in the opening image of this chapter (pages 58–59), which were part of a large display in the middle of a rotary intersection. Again, note the layering, palette-knife effect.

Opposite, top: 12–24mm lens, ISO 100, 1 second at f/16; opposite, bottom: Nikon D2X, 12–24mm lens, 4-stop ND filter, ISO 100, 2 seconds at f/16

FOR ME, THE FALL OF 2006 *proved to be one of the most colorful that I've ever witnessed and photographed in the southwest corner of Maine. My students and I had just returned to the parking lot from a short morning hike in the mountains, feeling quite satisfied with what we had already photographed. That feeling of accomplishment can be quite dangerous for us photographers, as a sense of complacency is usually not far behind. Even when one of the students called everyone's attention to "the most colorful tree I have ever seen," most of us looked and simply shrugged our shoulders, indifferent to what I, too, agreed was in fact the most colorful tree I had ever seen.*

"I have enough leaf shots," said one student. "I have enough tree shots," said another. Clearly all but one of the students were feeling fulfilled at that moment. As I watched this student point her camera up toward the backlit branches, isolating several leaves and shooting them against the deep blue sky, I noticed that I was beginning to feel, once again, a need to shoot. I walked over to that same most colorful tree and suggested that we both try a slow shutter speed while looking straight up and purposely spinning on our heels as we fired the shutter release. It didn't take long for the sounds of excitement to fill the air, and soon all of us were under that one big tree, pointing our cameras upward while spinning on our heels. Although a few minor collisions took place, we all felt that this was, in fact, one of the more remarkable and fulfilling mornings of image-making.

The image you see above is what I would call the classic fall shot, taken while looking up with a wide-angle lens. The second was taken while spinning on my heels.

Above: Nikon D2X, 12–24mm lens, ISO 100, 1/30 sec. at f/16; right: Nikon D2X, 12–24mm lens, 4-stop ND filter, 1/2 sec. at f/16

MANY OF EUROPE'S BACK ROADS *and meadows turn into carpets of red during the early part of May thanks to the perennial blooms of the red poppy. In fact, up in the north of France, near Lille and as far east as Strasbourg, you can see acres upon acres of red fields. I brought my car to a sudden stop when I rounded a corner on a small country road after having just passed a lone farmhouse whose entire yard— front, back, and sides—was rich in tall green grass and red poppies.*

After a quick knock on the door and receiving permission to take pictures on the property, I was soon immersed behind camera and lens. Of the many exposures I hoped to shoot that morning, motion-filled shots were high on my list. From the frontlit side of the house, I made this exposure of a rather ho-hum, somewhat static composition (left), but it possessed all the ingredients needed to make a wonderful abstract rendering of line, color, and texture. All I had to do was shoot it at a much slower exposure while simply moving the camera in a steady upward flow.

I made the first exposure at ISO 100 and f/11 for 1/250 sec. I made the second using both a Nikkor polarizing filter and my 4-stop ND filter, which resulted in a light loss of 6 stops. To recover these 6 stops, I simply readjusted my shutter speed from 1/250 to 1/125 to 1/60 to 1/30 to 1/15 to 1/8 to 1/4 sec., where once again my meter indicated a correct exposure. However, I stopped the lens down further by 1 full stop to f/16, which meant I now needed again to double my exposure time from 1/4 sec. to 1/2 sec. in order to return to a correct exposure. I then pressed the shutter release and simply moved the camera upward in a very smooth flow, resulting in the streaks of color and texture that you see opposite.

Left: 12–24mm lens, ISO 100, 1/250 sec. at f/11; opposite: 12–24mm lens, polarizing filter, 4-stop ND filter, ISO 100, 1/2 sec. at f/16

SIMPLY ZOOMING

As we've just discovered, there are a number of ways to bring life and movement to otherwise stationary subjects, yet I haven't touched on the simple and well-proven method of what I call "waking up the dead" via a simple twist or push/pull of the zoom lens. Tripod or no tripod, the choice is yours. Personally, I prefer to use the tripod for simple zooms, as it results in a cleaner image. And, just as with those spinning or jerking images for which you will find no lack of subjects, finding photographic subjects to zoom is just as easy.

WHILE TEACHING *a rainy and windy San Francisco workshop a few years back, one of several umbrellas died, but before retiring it to the garbage can, I decided to play with it, to bring it back from the dead, so to speak. I threw it down on the parking lot asphalt near a large white directional marker and soon was shooting several slow exposures while zooming with the camera on tripod. I set my aperture to f/11 and adjusted my shutter speed until 1/4 sec. indicated a correct exposure. As soon as I pressed the shutter release, I turned the zoom ring from 35mm to 70mm, and after making about twenty attempts, I felt confident that I had two or three that did, in fact, breathe new life into this once-dead umbrella.*

Opposite: 35–70mm lens, polarizing filter, tripod, ISO 100, 1/4 sec. at f/11

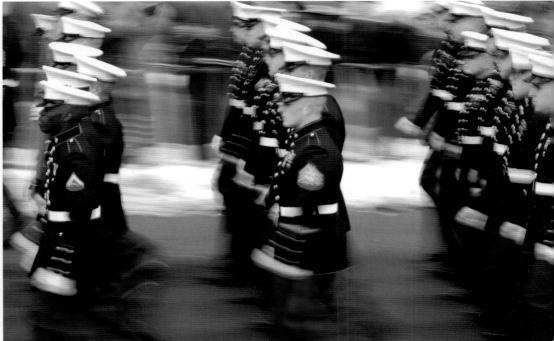

BASED ON MY LIMITED EXPERIENCE with the St. Patrick's Day Parade in New York City, it seems like a great excuse to hear some really fine Irish music, to feel a sense of pride as some of New York's finest march down Fifth Avenue, and, of course, to consume enough beer that if beer were an ocean, all the ships at sea would find themselves on the ocean floor by the end of the day.

The most recent St. Patrick's Day Parade I attended was a very cold one. Six inches of snow had fallen the night before, and the daytime temperature never got above freezing—all the more reason to keep the beer flowing, as many of the spectators found themselves outside on the sidewalks in front of bars big and small. At around 64th Street and Fifth Avenue, I managed to find an all-but-empty private grandstand and mounted the slippery aluminum steps, ending up at the top row, which provided me with a slight "aerial" view of the parade going by on the street below. As each group of police officers, firefighters, marines, and marching bands walked on by, I made it a point to pan in a right-to-left direction at a slow shutter speed (1/2 sec.) while at the same time zooming my 70–200mm lens. Of note in these images are the patterns formed by the colors and shapes. Pattern, one of the elements of design, is nothing more than a repeat of a single part of a subject across the frame, but much in the same way someone turns up the radio full blast, this repetitive design, in effect, turns up the volume considerably.

When shooting zoomed exposures, it's best to begin any composition you wish to zoom by framing it first with the widest angle of any given zoom and then zoom toward the longer end. So, for example, you begin with 17mm and zoom to 35mm or begin with 18mm and zoom to 55mm or begin with 70mm and zoom to 300mm. This effect will produce the desired results but not without practice. Don't be disappointed if your first few attempts don't measure up. You are either zooming too fast or too slow, but as with any other new technique, you will soon learn the rhythm required to make every zoom shot a success.

Both photos: Nikkor 70–200m lens, 4-stop ND filter, ISO 100, 1/2 sec. at f/22

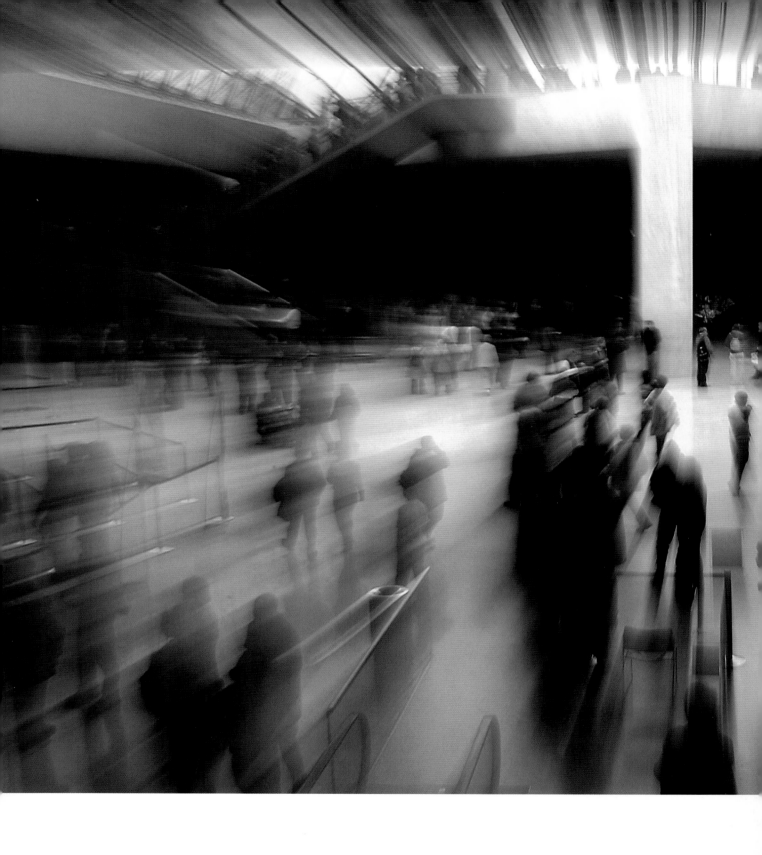

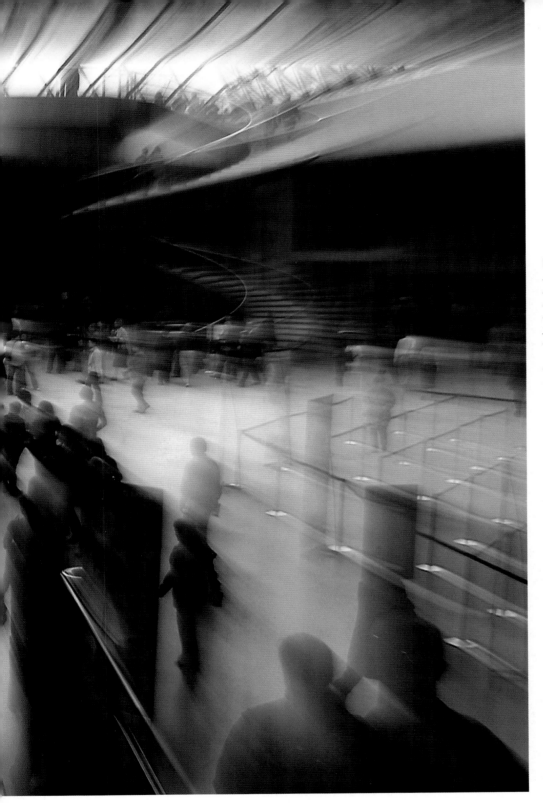

I HAVE A CONFESSION TO MAKE.
Several years ago, after spending no more than two hours at the Louvre in Paris, I began to get truly bored. (I can hear the gasps from some of you.) To be fair, I do love looking at art, but I am far more consumed with a passion for image-making, and after looking at the many, many beautiful works of many well- and lesser-known artists, I had simply had enough. I felt the need to shoot something, to create something, to make an image of just about any-thing. I just had to hear the sound of my shutter opening and closing, yet there I was with my wife and kids, who honestly seemed to be really enjoying themselves. Oh my, what's a father and husband to do at a time like this? Of course! Use the old "restroom" excuse.

With an agreement to meet up in about twenty minutes, I took off with my camera. Within minutes, I found myself back near the main entrance, where, it seemed to me, a lot of other bored people were standing around. With both elbows propped up on the circular railing and with my aperture set to f/11, I was able to record an exposure time of 1/2 sec. This proved plenty long enough to simply zoom my 17–55mm from 17mm to 55mm, and voilà—that once-bored-looking crowd of people was now full of energy, myself included! My photographic spirit had, once again, been renewed.

17–55mm lens, ISO 100, 1/2 sec. at f/11

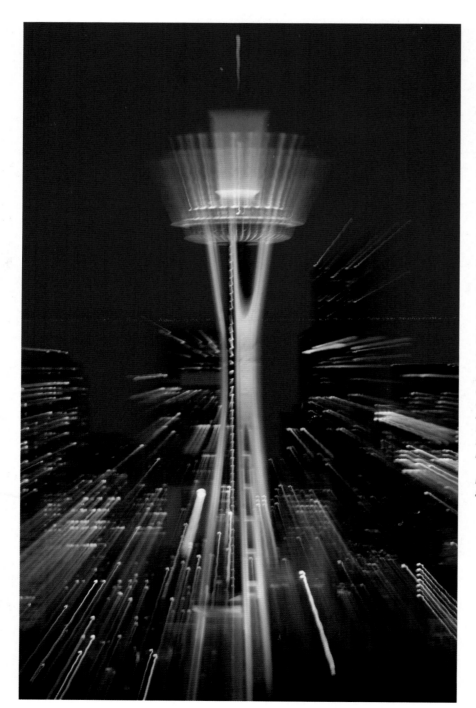

THE ZOOMING TECHNIQUE is often done by zooming from the widest angle to the narrowest angle in a fluid, smooth, nonstop motion. However, there is another zoom technique you may want to consider when shooting long exposures, such as those of 4, 8, or 16 seconds. Take a look at these two images of the Space Needle taken from Queen Anne Hill overlooking downtown Seattle. The first example (left) is a "simple" zoom: With my camera and 70–200mm lens mounted on tripod and my exposure set at f/16 for 8 seconds, I fired the shutter release and slowly began to turn to the zoom from its initial focal length of 120mm toward 200mm over the course of that 8-second exposure. The result is that the Space Needle and surrounding buildings appear to have "exploded."

In the second example (opposite), I chose to do something a bit different, something you can easily do when shooting any long exposure when the main subjects are stationary. I thought it would be interesting to see what would happen if I made three separate exposures at three different focal lengths of this same scene in just one image. With my exposure of f/16 for 8 seconds, I fired the shutter release and waited 2 seconds while the exposure was recording the scene at 120mm; then I carefully and quickly zoomed to 160mm and counted 2 seconds; and finally, I again carefully and quickly zoomed to 200mm and waited for the exposure time to close. As you can see in this example, it is still a "zoom shot," but it's much "cleaner."

Both photos: 70–200mm lens, tripod, 8 seconds at f/16

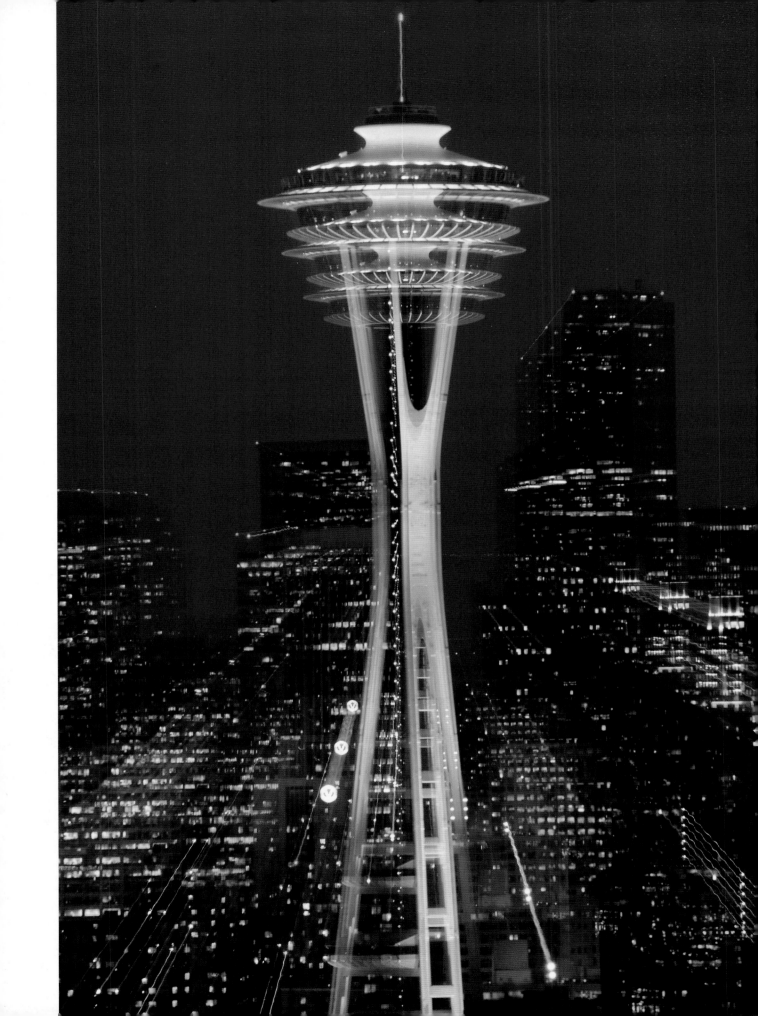

SINCE IT'S STRONG ENOUGH *to hold my Nikon D2X and fish-eye lens, I mounted the Bogen Magic Arm on the handle of a shopping cart and attached my two-foot cable release. As my wife's friend Catherine pushed her daughter, Victoria, through the aisles of the grocery store, I nonchalantly tripped the shutter with my cable release. With my camera set to ISO 100 and Aperture Priority mode, I found that when setting the aperture to f/16, the shutter speed registered a 1/2 sec. exposure. Also, since I was shooting under fluorescent lighting, I set my white balance (WB) to Fluorescent. Then I focused on Victoria and, again, merely tripped the shutter with my cable release as Catherine pushed the cart.*

Nikkor full-frame 14mm fish-eye lens, ISO 100, 1/2 sec. at f/16

The great folks at Bogen make a host of fantastic tripods, but they also make a bunch of accessories that allow you to put a camera just about anywhere you can imagine. One of my favorite gadgets of theirs is called the Bogen Magic Arm, which at its fullest extension is about twenty-four inches.

Another is Bogen's suction-cup clamp that in many ways is akin to a plunger. It sticks so well that it could give Super Glue a run for its money. With the "plunger" you can place your camera on any smooth surface, including walls, ceilings, and hoods of cars as they speed through tunnels (see page 102).

Then there is the Bogen Super Clamp, a really cool device that will allow you to attach your camera to most anything—skateboards, bicycles, a tennis racket, a putter—and record images from new points of view that will have your audience asking for more.

FOLLOWING PAGE *I used a dolly with a handle, something like a hand truck, to take this shot of a careless Rollerblader speeding through the streets of Lyon, knocking over pedestrians along the way. I was nowhere near this guy but, rather, was about ten feet to his left, running parallel to him as he pushed the dolly along the streets.*

So, where was the camera, and how did I fire the shutter release? The camera was mounted to the flat surface of the dolly with another favorite tool of mine, the Bogen Super Clamp. It was locked in place and facing the feet of the Rollerblader. Since I was using a focal length of 17mm, I was assured of recording a very wide angle of view. In addition, I had a Nikon radio receiver mounted on the camera's hot shoe, and as I ran, I triggered it with the Nikon radio sending unit I was holding, which fired the shutter each time I pressed the sending unit's button.

Since I couldn't control the exposure, I left the camera in Aperture Priority mode and set the aperture to f/22, knowing that the smallest aperture would force the slowest possible shutter speed. Of the more than sixty images I made during this shoot, this one best conveyed the sense of motion and disruption that a Rollerblader might cause if he or she remains oblivious to the surroundings.

17–35mm lens at 17mm, ISO 100, 1 second at f/22

THE BOGEN MAGIC ARM, in combination with the Super Clamp, opens the door to hundreds of possibilities for new and never-before-seen photographs. If your subject moves, you can now show the world how it moves.

Do you want to take a photo that's guaranteed to sweep your audience off its feet? Attach your camera to a broom and voilà: a broom's-eye view of the streets of Lyon. As you can see in the setup left, I attached the Magic Arm to the handle of the broom, along with the camera and my fish-eye lens. I had already prefocused the lens; at times like these, you do not use autofocus but instead prefocus the camera on the part of the scene that you wish to record in sharp focus. In this case, and since this is a view of the world as seen through the eyes of the broom, I chose to focus on the broom itself. Once my focus was set and with the camera in Aperture Priority mode, I simply adjusted the aperture, stopping down until 1/4 sec. was indicated as a correct exposure. I had determined from prior experience that 1/4 sec. easily provides the blurred-motion effect I was seeking. With the broom handle in my left hand, I fired the shutter release with my right hand while making gentle sweeps across the narrow street.

Fish-eye lens, ISO 100, 1/4 sec. at f/11

IT HAS BEEN YEARS SINCE *I saw the movie* Jacob's Ladder, *about a Vietnam vet caught between life and death. I really enjoyed it, and it was also during that movie that an idea came to me that, more than ten years later, I finally found the time and tools to create. If you've seen the movie, you'll no doubt recall the somewhat ghoulish-looking characters that would show their faces on subways and in cars. I wanted to re-create this idea while driving a car through a tunnel in France.*

With a Bogen Super Suction Cup (and boy, do they mean super suction), I was able to mount my camera and fish-eye lens on the hood of my friend Phillipe's car (above), intent on firing off a number of exposures as we drove through several long tunnels. I was the passenger and Phillipe was driving.

Of course I wanted to record a sense of motion, which meant I would need a slow shutter speed of at least 1/2 sec., if not 1 second. And in order to determine what aperture I would need to use at these speeds, I needed to take a meter reading under a lighting condition that would be similar to the light in the tunnel. Getting that meter reading actually proved rather easy: We first drove through the tunnel without the camera mounted on the car; I opened the sunroof, stood up through it, and shot down onto the hood of the car to take a meter reading. With ISO 100 and Aperture Priority mode, I found that f/8 got me a correct exposure with 1/2 sec., and at f/11, the correct exposure was 1 second. After this first trip through the tunnel, we exited and pulled off to the side of the road. With the bright interior dome light on inside the car, I took another reading of Phillipe's face and discovered that at f/11 I could also get a correct exposure at 1 second. I had the "numbers," and now we were all set.

I chose to leave the camera in Aperture Priority mode, rather than in manual, knowing that if I set the aperture to f/11 the camera would record a correct exposure somewhere in the neighborhood of 1 second, depending on the varying degrees of brightness as we drove through the tunnel. So, with the camera in Aperture Priority mode, the lens set to f/11 and pointed at us, and with the Nikon remote receiver mounted to the camera, we were ready to begin our journey through several long tunnels—but not before donning our ghoulish masks. I wanted this to be a "ghoulish dream" kind of photo. As we drove through the tunnels, I simply fired the camera from inside the car with the Nikon remote sending unit.

After making several trips through the tunnels, we pulled over, and I began a quick review of the images made so far. Two things were immediately apparent: Most of the exposures were spot on, but Phillipe and I were a bit too blurry in most of the shots. It was clear that we needed to settle down, temper our excitement, and sit as still as possible. So, off we drove once more, donning our masks.

I am pleased to say that this last run through the tunnel proved to be the best of all. And just a note: Phillipe's car is actually light blue. Once inside the tunnel, it recorded an odd bronze cast that no amount of Photoshop could repair. While trying to recover the light blue color in the computer, I came across this wild purple color, and the more I viewed it, the more I liked it, so a purple car it is! This color was the result of playing with both the Color Balance and Hue/Saturation controls in Photoshop.

17–55mm lens, ISO 100, 1 second at f/11

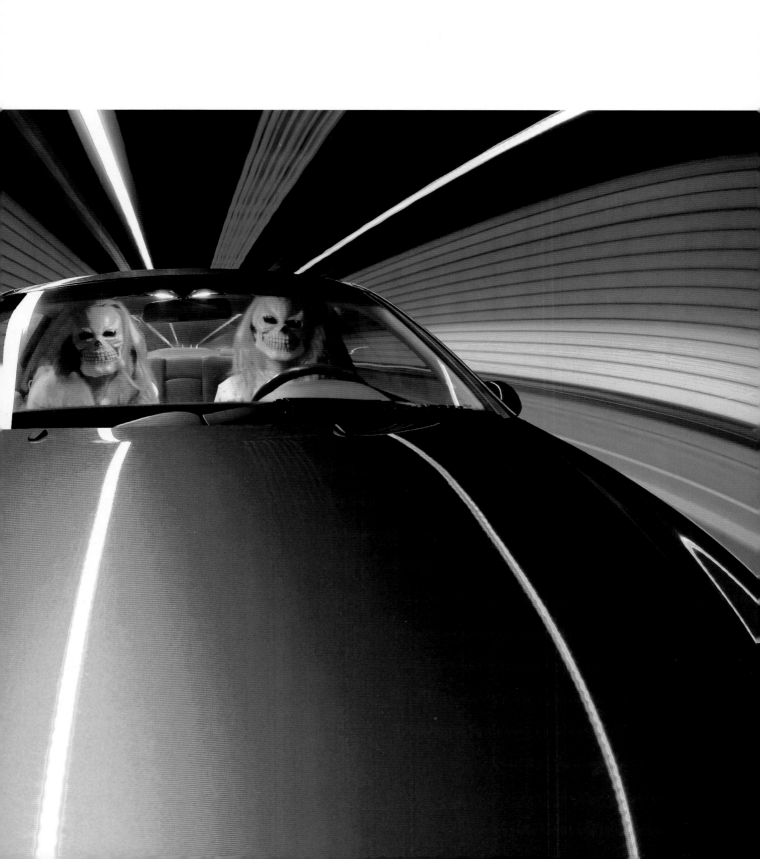

DUSK AND LOW LIGHT: 1 SECOND AND BEYOND

There seems to be this unwritten rule that before the sun comes up or after the sun goes down it's really not possible for most shooters to get any good pictures. The three reasons for this that I hear today are the same three reasons I heard years ago: (1) "There is not enough light," (2) "You need one of the more expensive cameras, don't you?" or (3) "I don't know how to get a meter reading." But as the images in this section will show, there is *always* enough light, and getting a meter reading couldn't be easier, as I will explain to you. Truth be told, I'm convinced that the real reason most photographers don't venture out at night to shoot is because shooting at these hours of the day *can interfere with one's lifestyle* (just ask my wife and kids!).

Low-light and night photography do pose special challenges, not the least of which is using a tripod (assuming, of course, that you want to record exacting sharpness) and some degree of mathematical skills (simple addition or subtraction) in some cases to come up with a correct exposure. But again, it is my feeling that the greatest hindrance to shooting in the low light of predawn or at night is in the area of self-discipline. "It's time for dinner." Pack a sandwich. "It's time to go to a movie." Save your money and rent the movie when it comes out on DVD. "It's time to go to a party." Show up an hour or two later, fashionably late. "I'm not a morning person." Then don't go to bed the night before. "It's time to watch my favorite television show." Tape it, TiVo it, see it after you're done shooting. "My friends are waiting for me back at the car." Make photographer friends who will gladly join you on the shoot. "I'm all alone and don't feel safe." Again, make photographers your friends, or join a camera club. "I don't have a tripod." Buy one!

In both my on-location workshops and online courses, students quickly learn just how much photographic opportunity exists before the sun comes up and after the sun goes down. And the rewards far outweigh the sacrifices. If it's your goal to record compelling imagery—and it should be—then low-light and night photography are two areas in which compelling imagery abounds. With a little planning and a little forethought, you can soon find yourself in countless locations to shoot some showstopping exposures. Once you've arrived at a given location and conclude that *this* is where you will set up, the only question that remains is how to set the exposure for the upcoming "light show."

With the sophistication of today's cameras and their highly sensitive light meters, getting a correct exposure is commonplace, even in the dimmest of light. Yet this is an area in which many photographers often find themselves under a cloud of confusion: "Where should I take my meter reading from? How long should my exposure be? Should I use any filters?" In my years of experience in taking meter readings, there is nothing better nor more consistent than taking a meter reading off of the sky—whether I'm shooting backlight, frontlight, or sidelight, or whether I'm shooting the first light of dawn or the last remnants of light at dusk.

What should my exposure be when shooting in low light or at night? Now, that's a really good question, but by now, you should know the answer or feel a lot closer to being able to answer it. Your exposure will be based on the very same principles of creative exposure as we've been discussing throughout this book. Does the scene present any motion-filled opportunities, or are you simply shooting a classic skyline of some city, large or small? Either way, the principles of metering and where to take a meter reading from are the same, *but* if there's motion involved (such as the flow of traffic), then you do have the option of setting an exposure that will render that flow of traffic as fluid streaks of color.

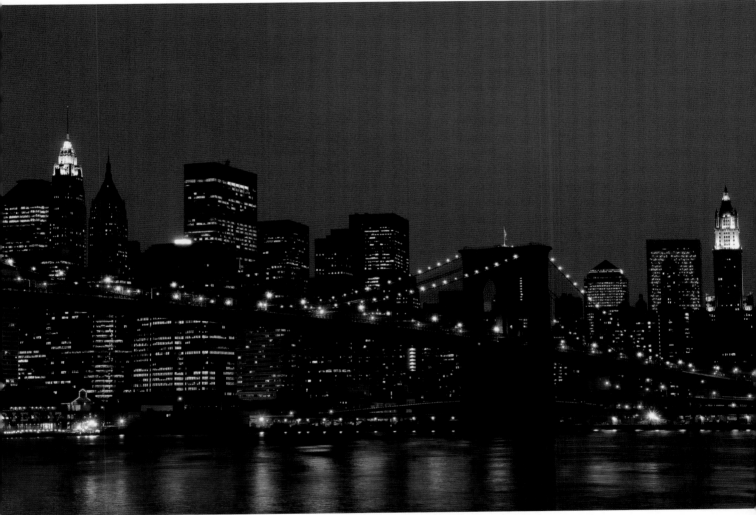

WHAT BETTER PLACE *to try your hand at nighttime exposures than the greatest city on earth: New York! And it's a simple exposure, too! With my camera on a tripod, I raised the camera to the dusky, partially cloudy sky above (top) and adjusted my shutter speed until 2 seconds indicated a correct exposure. I then recomposed the scene, fired the shutter release, and, just like that, had my dusky nighttime exposure of the Big Apple.*

Since this scene didn't present any real motion-filled subjects, it wasn't necessary to increase my exposure time longer than 2 seconds. I've often caught my students shooting an exposure like this with apertures of f/22 and shutter speeds of 15 seconds; when questioned about the logic behind such a long exposure, they are hard-pressed to give an answer, since the "same" exposure can be achieved at larger apertures (f/8) and shorter shutter speeds (2 seconds) in the absence of any motion-filled opportunities. This is something to keep in mind, especially if you find yourself out shooting dusky scenes such as this in temperatures below freezing.

17–55mm lens, tripod, ISO 100, 2 seconds at f/8

FOR SOME YEARS NOW, *the city of Lyon has been holding the Fête des Lumières festival every December, partly in honor of the Lumière brothers (who are responsible for the birth of film, as in "going to the movies"), and one main attraction is the largest Ferris wheel on the European continent, which arrives every year from Germany. With my camera on a tripod and my aperture set to f/11, I simply adjusted my shutter speed until 4 seconds indicated a correct exposure off of the dusky blue to the left of the Ferris wheel. Basically, I metered this scene off of the dusky blue sky, just as I did for the New York City skyline on pages 2–3. Since it wouldn't make any sense to shoot a 4-second exposure if the ride was not moving, I waited a few minutes for it to fill up with people, and soon it was making revolution after revolution.*

70–200mm lens, tripod, ISO 100, 4 seconds at f/11

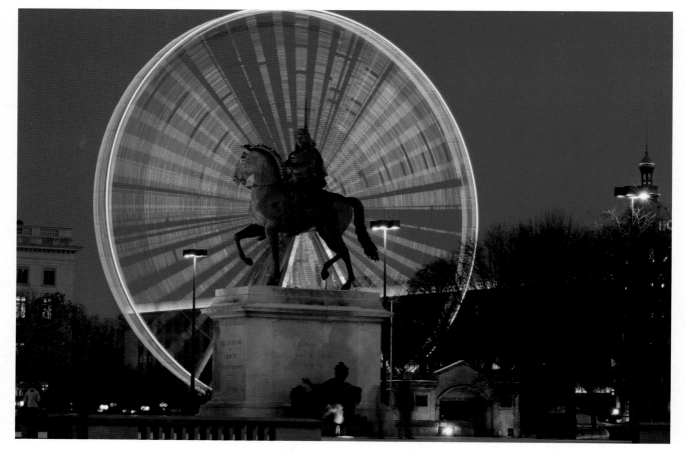

So, for example, if you wish to shoot a simple exposure (and I really do mean simple) of a city skyline in manual exposure mode, set your aperture to *f*/8, raise the camera to the dusky sky above the cityscape or landscape, adjust your shutter speed until a correct exposure is indicated, and then return to your composition and press the shutter release. It's important to note that it's entirely possible that once you return to your composition, after you've set the manual exposure, your meter may indicate an underexposure, but just ignore it and shoot. The underexposure indicated is in response to what the meter sees as dark buildings, but in this case, the meter has been fooled, as the buildings really are not all that dark.

If you prefer to shoot scenes like this in some kind of auto (Aperture Priority mode, for example), again set the aperture to *f*/8, and while pointing your camera to the dusky sky, hold your exposure-lock button and then recompose and shoot. The exposure lock will "save" the exposure for the dusky sky, so when you shoot, it will be at the dusky exposure. Chances are, in either case, and with ISO 100, *f*/8 will render an exposure time of about 2 or 4 seconds. If you are, in fact, shooting a motion-filled scene, set your aperture to at least *f*/11, if not *f*/16, which in turn will increase your exposure time to 8 to 16 seconds. The longer the exposure time, the greater the amount of motion recorded in the image.

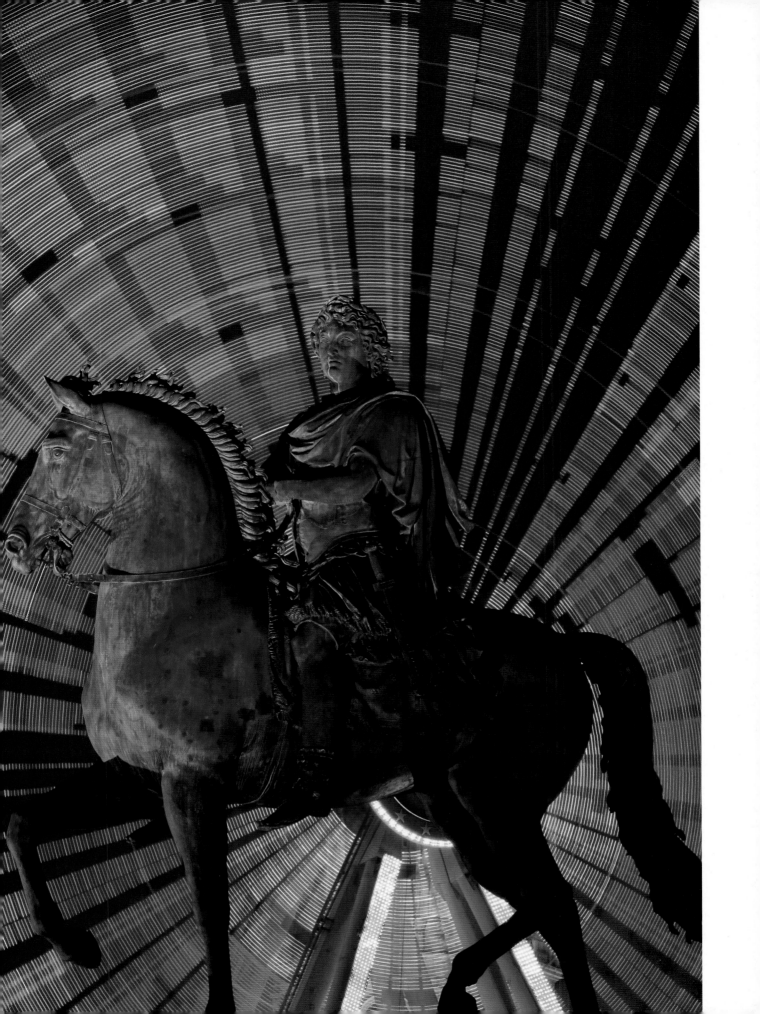

THE DENSE FOG *that greeted me at Pigeon Point in California allowed me to record, over a long exposure time, a terrific lighthouse beam. With my camera mounted on a tripod and set to Aperture Priority mode, I first set the aperture to f/8 and noticed that the appropriate shutter speed was 2 seconds. Since this scene was dominated by a pea-soup kind of fog, the exposure levels throughout were quite even, except, of course, for the lighthouse beam and small lights on the surrounding buildings. The relatively even light levels were the reason I chose to shoot in Aperture Priority. As the day turned to dusk, the overall color temperature of the light began to fall, and the once-gray light turned blue. In addition, my exposure time increased from f/8 for 2 seconds to f/8 for 15 seconds. This longer exposure allowed me to record the beam and also made the normally wild and crashing surf calm and ethereal.*

It's important to note, when shooting a scene such as this, that you begin your exposure as the light makes its first beam out in the fog. Over the course of a 15-second exposure, you should be able to record at least two if not three passes of the beam, depending, of course, on how long the beam takes to make a full 360-degree sweep. Also, it has been my experience that you won't record much of a beam unless there's a good layer of fog.

And finally, in response to the common question of "Hey Bryan, when is a good time to shoot a vertical composition?" my answer is always the same: The best time to shoot a vertical is right after you shoot the horizontal!

Opposite, top: 70–200mm lens, tripod, ISO 100, 2 seconds at f/8; opposite, bottom: 70–200mm lens, tripod, ISO 100, 15 seconds at f/8

SAN FRANCISCO IS A CITY that many would swear is the only city worth bragging about, but for me, it will always be a city that I could never quite get my head around. Don't get me wrong. I find San Francisco to be a photographer's paradise; but try as I might, including living there, I could never embrace it as a city that I could call home. I'm sure it will be one of those cities that even if I were to live there again, I would still feel that I was only a visitor.

Still, from atop the steep incline on Treasure Island, a truly magnificent view of the city awaits. For my first attempt with my tripod-mounted camera and 70–200mm lens (below), I chose an aperture of f/11, and with my camera pointed into the dusky blue sky to the right of the bridge, I adjusted my shutter speed until 4 seconds indicated a correct exposure. At this slow shutter speed, I was able to record the slow but steady flow of traffic heading into the City by the Bay.

I was not done, however. One of the many realizations my students come to in my on-location workshops is that many of their wonderful compositions do in fact have additional photographic opportunities inside the frame. So, as idyllic as this scene of San Francisco is, I knew there was still at least one other dynamic image to be made: an image that was primarily devoted to the strong graphic elements of line and color. I switched to my 200–400mm lens, again set the aperture to f/11 and the shutter speed to 4 seconds, and composed this vertical composition of just the bridge.

On your next outing, take a closer look inside your viewfinder, and see if, in fact, you have another photographic opportunity to shoot. You might discover that you have been moving on to the next great shot too prematurely.

Below: 70–200mm lens, tripod, ISO 100, 4 seconds at f/11; opposite: 200–400mm lens, tripod, ISO 100, 4 seconds at f/11

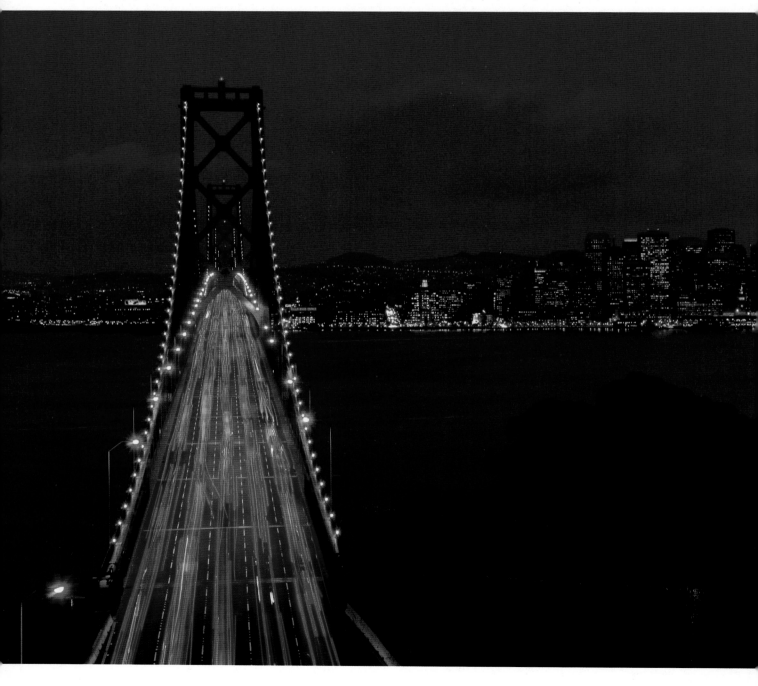

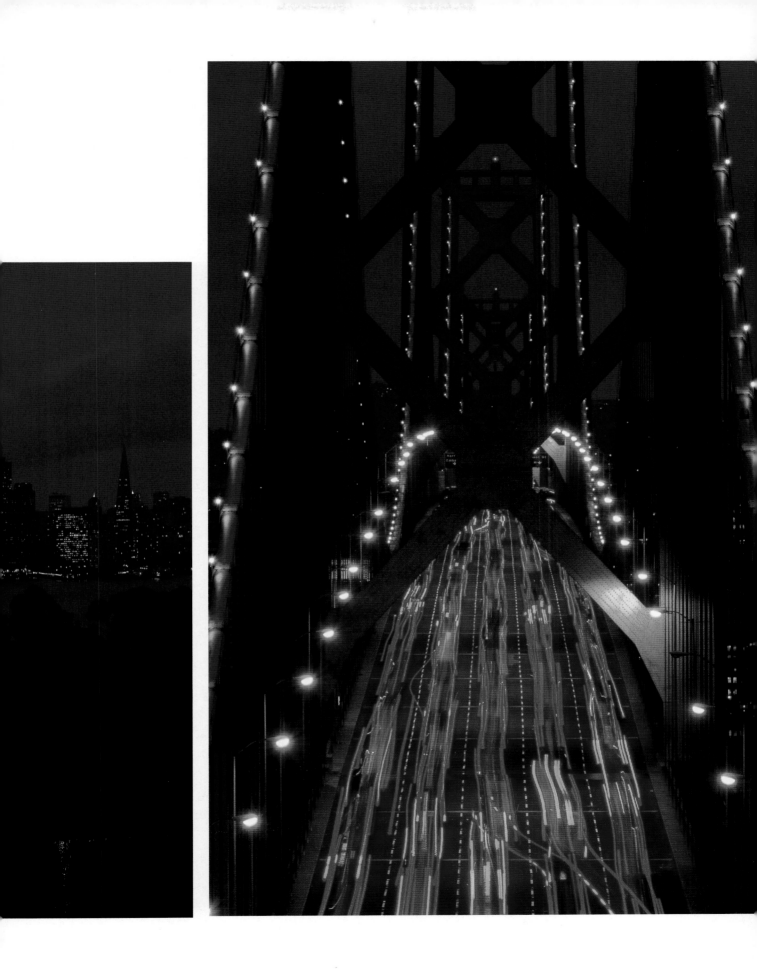

TO CAPTURE THIS "GHOST," *I found myself going into the "cave" of my own apartment building. With my tripod-mounted camera set to ISO 100 and my 12–24mm lens, I set up the compositon you see here, and with the aperture set to f/8, I adjusted my shutter speed until 8 seconds indicated a correct exposure. Ghosts are shy by nature, and I've found that it takes about 8 seconds for them to reveal themselves to you. It's important that you stand very still, too, since any disturbance to the air could cause the ghost to flee. Of course, whether you believe in ghosts or not is not important; but if you do believe that this kind of time exposure is fun, then you'll be interested in learning just how easy it is.*

The idea for this shot was originally born after both of my daughters had watched the movie The Ring. *When I told Chloë and Sophie how easy it was to make your own ghosts, they, of course, were all ears, and it was Sophie who won the coin toss to play the role of the ghost. Outfitted with a white dress and no shoes, Sophie simply stood in the dirt floor hallway of the "cave." She stood in that same spot, holding perfectly still, for the first 4 seconds of my 8-second exposure. Then, at the end of 4 seconds, she bolted out of the picture, to her left, in fact, where there was another short hallway. Since she was only in the shot for half of the exposure time, she recorded only as a transparent, ghostlike subject. Pretty neat, eh?*

12–24mm lens, tripod, ISO 100, 8 seconds at f/8

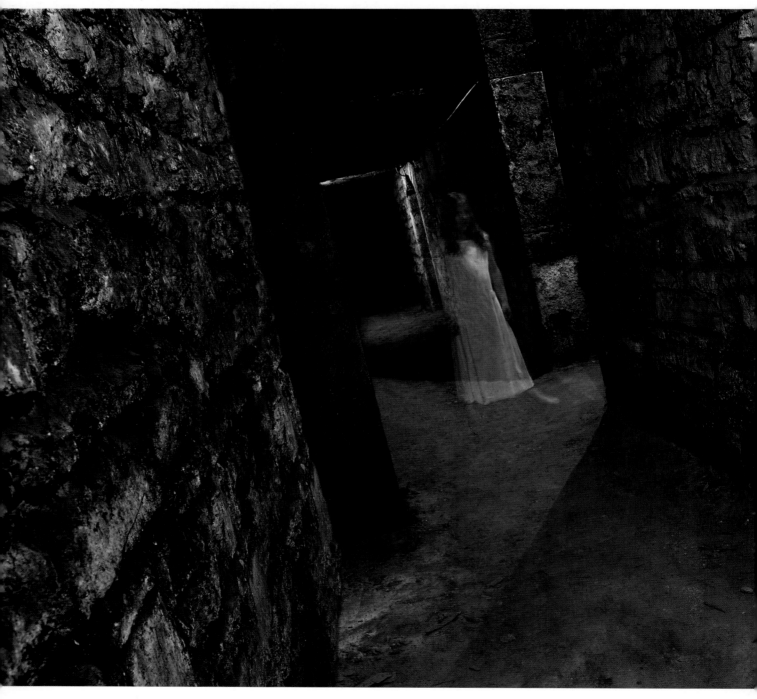

THERE ARE BUT TWO IMAGES *in this book for which the use of Photoshop was pivotal to the success of the image. The first is the image on pages 22–23 in which I not only placed a different sky in the shot but also altered the overall color of the image, making it predominately blue. The umbrella appeared exactly as you see it. On command, one of my students threw it in the air, and the strong wind carried it forward into the composition, startling some of the pigeons of Piazza San Marco into flight. (To stop action, I shot at 1/500 sec.)*

The second image making obvious use of Photoshop is this one of my angel, Kathy, which is actually three images assembled and masked together. What's most important, however, is that the success of all three of the images used relied on my getting the exposure right in camera and on my calling upon the correct and most creative shutter speed. First and foremost, I needed the perfect cloud shot, which I took from my airplane window seat, holding my camera right up to the window; using Aperture Priority mode, I adjusted the aperture until 1/500 sec. indicated a correct exposure. For the second image, I rented a small gas-powered generator that let me use two portable house fans to provide the wind effect. I had Kathy stand up on a white chair in the middle of a plowed field with both fans on the ground pointing up at her. Since I wanted to record some subtle blurring in her hair and gown, I used a slower shutter speed of 1/4 sec. And finally, it was on a trip in Tampa, Florida, that I shot a number of shore birds flying low overhead at the action-stopping shutter speed of 1/500 sec. Combining all three photos with the help of Layer Masks in Photoshop allowed me to produce this one-of-a-kind fantasy image you see to the right.

How do you photograph ghosts and angels? First, it's critically important that you believe in both. Second, photographing either can be quite tricky but the rewards that await you will be many. Once word gets out that you've photographed one or the other, you'll soon be featured on the Dicovery Channel, perhaps A&E, and for sure, you stand a great chance of having your photographs published on the cover of the *National Enquirer*. Are you ready to go ghost and angel hunting? Let's go!

The first place to go looking for ghosts, of course, is old Victorian-style homes, particularly those in the New England area. Since you can only see ghosts at night, that means long exposures and bringing your tripod. When it comes to seeking out angels, you must bring along an ordinary house fan (which also means you need a small gas-powered generator or a long extension cord if you choose to shoot your angel outside); this is because angels are only made visible by the subtle wind that blows across their heavenly bodies. And, to capture the subtlety of this wind, shutter speeds of 1/4 sec. are the norm.

EXPOSURE
CONCERNS

WB ISSUES

I am often asked about white balance (WB) when shooting digitally, and I have finally concluded that leaving my WB set to Cloudy for 99 percent of my shooting suits me just fine. The Cloudy setting simply warms up every image by adding red to the overall scene. Red translates into a warmer, more inviting image. If your camera doesn't offer a Cloudy setting, but rather settings for Kelvin temperature, set the WB to 5,900 K.

Of course, you may not like using Cloudy, but more important, WB and WB settings are an often-overrated topic. If you are like most digital shooters out there and shooting in raw format, you can always change your WB to any color temperature you wish. But if you insist on shooting JPEGs, then I would still strongly suggest that you consider setting your WB to Cloudy, especially since most photographers who shoot primarily in JPEG format are also photographers who don't ordinarily shoot in the early morning or late afternoon; adding warmth to much of your midday photography will only help the overall look and feel.

EVEN THOUGH *I do have my WB set to Cloudy, because I shoot in raw format, I also have the liberty to change my WB, and about the only time I have found this useful is when shooting time exposures, particularly city scenes. Sometimes, I find that a city skyline is more appealing when it's seen and printed in its "original state." The Kelvin temperature of city scenes and dusky blue sky are actually around 3,200 K, and when the camera is set to Cloudy (5,900 K), the resulting image is much warmer than the truer, cooler, and bluer 3,200 K. In these two examples of the Seattle skyline, the original image (top) is warmer (5,900 K), while the other is much cooler (3,200 K). That's the only difference between the two.*

Again, if you're shooting raw and if you normally shoot your city scenes around 5,200 K to 6,000 K, consider going down to the much cooler temperature of 3,200 K. The results might be just exciting enough to turn a ho-hum cityscape into a real showstopper.

Opposite, top: 17–55mm lens, tripod, ISO 100, 4 seconds at f/11, 5,900 K; opposite, bottom: 17–55mm lens, tripod, ISO 100, 4 seconds at f/11, 3,200 K

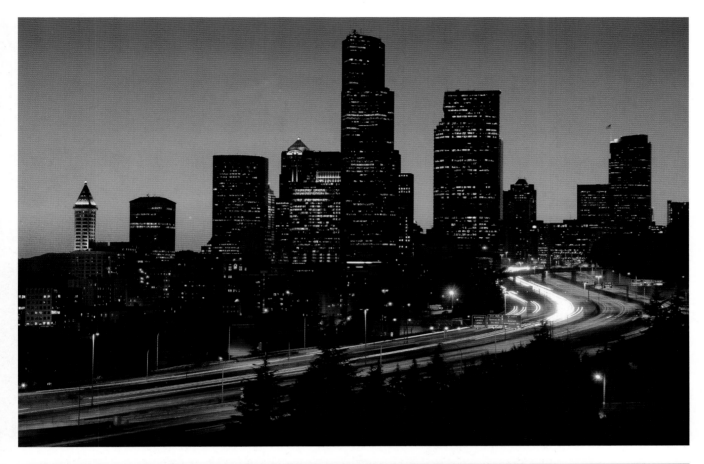

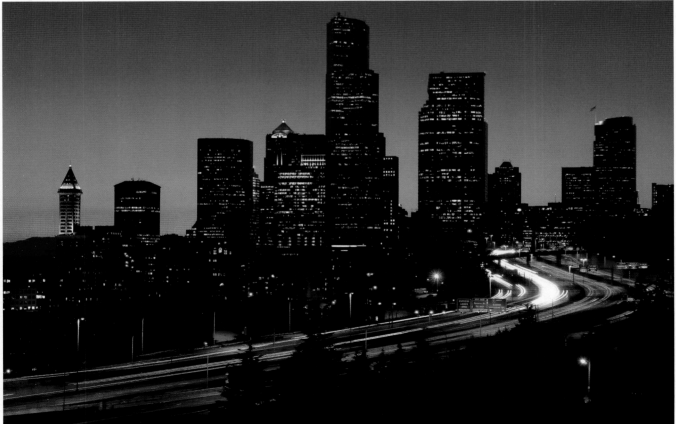

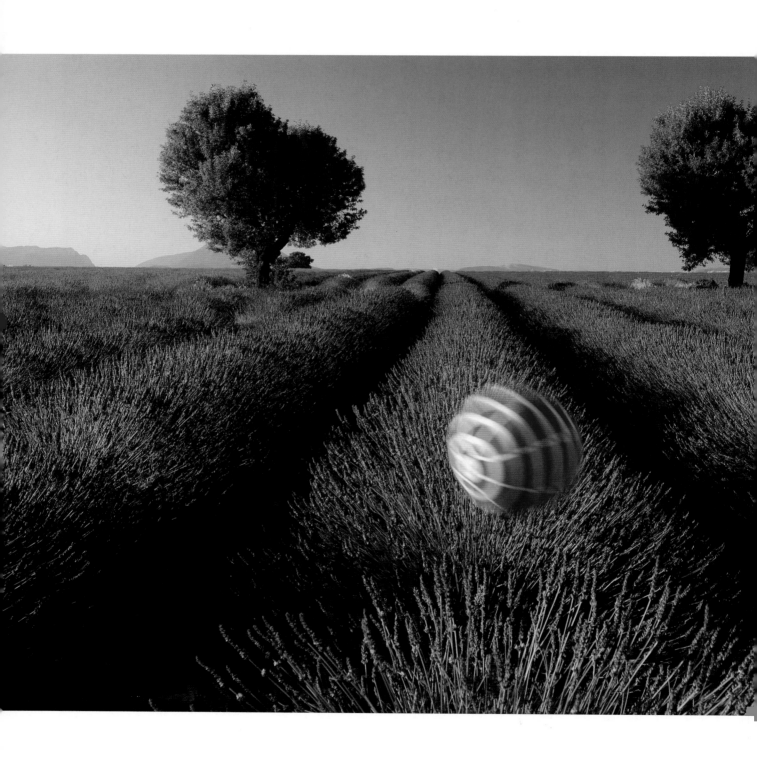

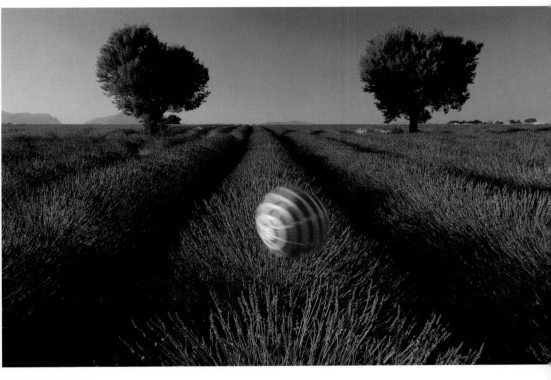

I SHOT THE IMAGE *to the left (in the Valensole Plain of Provence, France) with the Cloudy white balance setting. The image above shows the same image with the white balance setting changed to Auto in Photoshop. The Cloudy version is clearly the warmer of the two photographs.*

Both photos: Nikon D2X, Nikkor 12–24mm lens, polarizing filter, 1/30 sec. at f/16

LONG EXPOSURES AND REAR CURTAIN FLASH SYNC

Imagine setting up your camera and lens on a tripod in a darkened room, almost black. You set the camera's shutter speed dial to 15 seconds, your aperture to *f*/11, and you finish everything off by powering up your flash, making certain to set it to the often-overlooked setting of *rear curtain sync* or *second curtain sync*, depending on your camera. Rear curtain sync is a really simple idea to understand, and it goes like this: When you use your flash set to its default setting, the flash fires at the *beginning* of the exposure. It is, for all intents and purposes, the *main* light source in your photo, and any other lights that might be on (or any other daylight that might be in the overall scene) will take a backseat, in terms of their exposure, to the flash exposure. When the camera's flash is set to fire in rear curtain sync mode, the flash doesn't fire until the *end* of the exposure. Note that I'm talking of an exposure time lasting anywhere from 1/250 sec. to several minutes or even hours, depending on what you're shooting.

Just think of what kind of fun and creative exposures you can achieve with this kind of setup! If the many photo contest entries and student works I have reviewed over the years are any indication, the prospects are countless. It's about time you get enlightened, pun intended!

I REMEMBER THAT *unmistakable jolt I experienced as a kid when I tried to rescue my piece of burning toast from the toaster with an ordinary butter knife—while the toaster was, of course, still plugged into the wall. Yeeowww! At the time I had no idea that I would one day resurrect that experience photographically. Thanks to my daughter Sophie's willingness, I was able to re-create that fateful day.*

After choosing this particular corner of the kitchen, making certain the toaster and counters were spick-and-span, and making sure, too, that the circuit breaker had been cut to that particular outlet, I focused on the composition you see here before turning out the overhead light. I also had set up behind myself and to the right a White Lightning Alien Bee monolight inside a soft box, pointed up toward the kitchen ceiling. Plus, I had changed my flash setting on the camera body to rear curtain sync.

With my monolight at full power and with the aid of my flash meter, I first fired the strobe manually and recorded an exposure of f/16. That is to say that if I set my lens to f/16 at any shutter speed from 1/250 sec. to as long as 4 to 8 and 15 to 30 seconds or even longer, I would record a correct exposure of the area before me that the flash could reach. In this case, the flash didn't have to reach far, since the scene before me was all but three to four feet away from the camera.

As far as the shutter speed, I estimated that I would need about 15 seconds tops to add my "dose" of creativity, which in this case was a simple sparkler. Okay, so the shutter speed was set to 15 seconds, the aperture was at f/16, and the rear curtain sync was engaged, so at the end of 15 seconds that flash would fire, and whatever happened during those 15 seconds was on my shoulders.

After pressing the shutter release, I immediately lit the sparkler, at first with my back to the lens so that the lighting of the sparkler wouldn't be part of the exposure. I then quickly went to work in outlining Sophie, the toaster, and the electrical cord with the sparkler, making certain that my body was not blocking all of the outlining I was doing. This meant, for the most part, that I was doing my outlining from the far right or far left of the frame. Sophie had already been coached to exhibit a shocked expression. As the time wound down toward 13 seconds, she put her face on, and two seconds later, I was out of the picture off to the left when the flash fired at the end of the 15-second exposure.

Nikon D2X, 17–55mm lens, tripod, 15 seconds at f/16

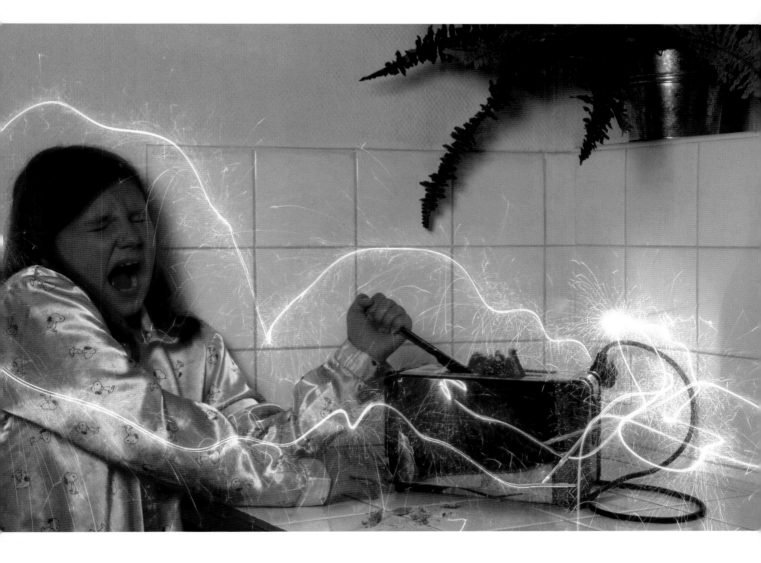

YOU DON'T HAVE TO GET FANCY

Don't start thinking that the idea shown on the previous page has to be done with some fancy monolight or studio strobes. It doesn't! You can use your own portable flash—you know, the one that you mount on top of the camera's hot shoe. You will also want to point the flash up, at about a 60-degree angle toward the ceiling so that the flash filling the room is "softer"; leaving it pointed straight out into a room often leads to hard shadows.

Choose any well-lit room and set your camera to Aperture Priority mode, choosing an f-stop of f/11. Then simply fire the shutter and see for yourself if the flash recorded a correct exposure of the scene before you. Chances are really good that it did, as most flash today uses through-the-lens metering, which simply means that the flash is able to determine, automatically, how much flash is needed based on your aperture choice. If you check your digital monitor and discover the flash output is a bit too dark or too light (highly unlikely, by the way), you can make adjustments on the back of your flash by increasing or decreasing the flash output. If the flash exposure was good, you can now mount the camera and lens on a tripod and set your shutter speed for the length of time you feel you need to light whatever it is you wish to light with your sparklers, flashlight, laser pointer, or, heck, all three!

When you're ready, turn off the room lights, fire the shutter, and start your light show. If, by chance, your flash should fire as soon as you press the shutter release, you either (1) did not set it up for rear curtain sync or second curtain sync, or (2) the flash has simply fired a small dosage preflash. The latter is the more likely culprit with all TTL flashes; it's a way of calculating the actual correct amount of flash needed at the end of the exposure. And don't worry about this preflash being influenced by what you do with your sparklers, flashlight, or laser pointer. It won't see a thing.

WHEN MY DAUGHTER CHLOË *got this very nice guitar for her birthday a few years ago, she couldn't yet play. For two years, it sat there in her room, untouched for the most part, on that very nice guitar stand my wife and I also bought her. So I decided it was time to try to "cash in," so to speak, and get some shots of her "playing" her guitar out on the small terrace of our apartment. I purposely chose to do this at dusk, against the backdrop of Old Lyon, and this proved, once again, to be a really easy exposure— and it would have been for you, too, I'm sure.*

With my tripod-mounted camera set for ISO 100 and my 17–55mm lens set to f/11, I took a meter reading from the dusky blue sky and adjusted my shutter speed until 4 seconds indicated a correct exposure. I estimated that the time I needed to "paint" the area around Chloë with sparklers would be about 8 seconds, so I stopped the lens down to f/16, which, in turn, increased my exposure time from 4 to 8 seconds. Again, with my single Alien Bee monolight in a soft box, mounted on a stand to my right, and pointed straight at Chloë, I fired off several test flashes while holding the flash meter in front of her and adjusted the flash head until an aperture of f/16 was indicated. I now had my flash output requiring the same exposure of the ambient (available natural) light. All that remained was to set my camera to rear curtain sync, which I did. I then had Chloë grab her guitar, stand on the deck, and hold still while making a screaming rocker expression. At the same time, I "painted" the area around her with a sparkler for about 7 seconds and quickly got out of the way as the flash fired at the end of the 8-second exposure. P.S. Chloë does now, indeed, play her guitar for real.

17–55mm lens, tripod, ISO 100, 8 seconds at f/16

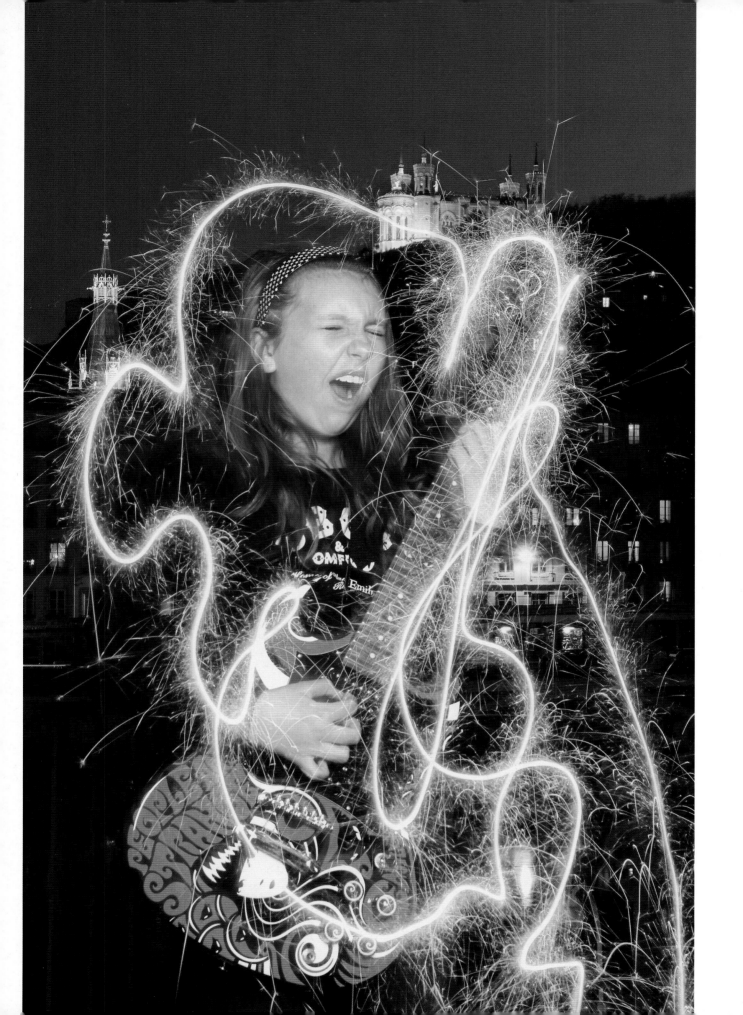

NOISE

Perhaps you have read about "noise" being a concern when shooting long exposure times. As I explained earlier in the section on ISO, noise, or grain, is normally associated with ISO: The higher the ISO, the more noise or grain appearing in the image. However, long exposures also create noise. There is a breakdown in the image sensor's ability to expose for long periods of time, and for lack of a better description, it's as if some of the pixels are unable to do the job assigned to them; as a substitute for not recording the correct color/contrast, they will resort to recording white or silver-looking specks. These white or silver-looking specks become even more pronounced when you sharpen a digital image. In fact, many shooters don't even notice the noise until they sharpen their image in a program like Photoshop. The reason the specks become more noticeable is that sharpening an image boosts the pixels' luminance, and since the "bad" pixels are either white or silver to begin with, the white or silver specks are made even brighter by sharpening.

So, what is meant by long exposures? As of this writing, I've found that noise becomes quite apparent on exposure times longer than 15 seconds. For the most part, that should have minimal effect on most shooters, since most of us are not inclined to shoot exposures much longer than 15 seconds and, more than that, since the industry has made great strides in developing new sensor technology. I expect that one day we'll see the topic of noise fall off the radar.

Of course, most of us do want to sharpen our images when making prints, so until the problem of noise has all but been eliminated with new technologies, what's the solution? For starters and as already discussed, use low ISOs so that noise will be kept to a minimum. Secondly, if you still have obvious noise problems, you can call upon a number of plug-ins on the market that reduce, if not eliminate, noise in postprocessing. Noise Ninja and Kodak's Digital Gem are two of the most popular, and both are available for download and purchase online.

MOST EVERYONE HAS *heard of, if not read or seen,* The Da Vinci Code. *Thus was the inspiration for this photo born. I found Silas, one of the truly bad guys in the book, a fascinating character for many reasons, including the fact that he was a man committed to the cause at any cost and, of course, that he had an amazing tolerance for pain. Silas was often in the shadows, both literally and figuratively, scurrying toward something or someone or scurrying away from something or someone—and this was how I wanted "my Silas" to appear, as well. It made sense to use a church, lit at dusk, for a backdrop, and it made even more sense to cloak Silas in black with just a touch of light on his face. The solution to achieve this: rear curtain sync.*

My daughter Chloë donned a mask and black hooded cape, and I was soon getting my desired results. And, to really emphasize the simplicity of this "trick," I didn't use any of my so-called "professional equipment," but rather my Leica D-LUX 3 digital point and shoot. Before I called upon Chloë, I got down low, looked up at the church and dusky blue sky, and took an exposure in Aperture Priority mode with the lens set to f/4 and my ISO at 200. The actual exposure time was 1/4 sec. Perfect, since I felt that if Chloë would simply stand in what was a dark foreground, I could just take this same exposure as I framed her with the church behind her, while at the same time using the camera's built-in flash set to rear curtain sync, of course. And as I shot her, I would simply move the camera upward during the 1/4 sec. exposure.

As you can see, this upward movement recorded an exposure of a "moving" church, while at the same time, the flash exposure on Chloë didn't fire until the end of the exposure, thus capturing the mask in all its detail. During the first part of this 1/4 sec. exposure, the ambient light that was falling on the mask was so minimal that none of it was able to record an exposure until the mask was lit by flash.

Leica D-LUX 3, ISO 200, 1/4 sec. at f/4

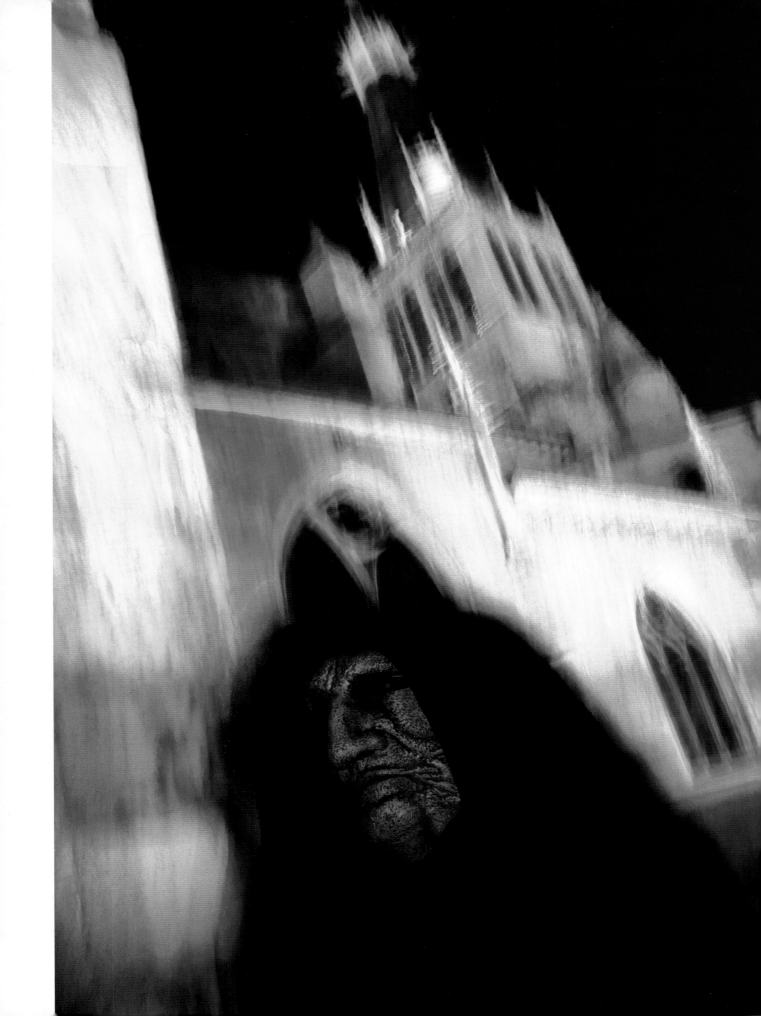

IF YOU'VE EVER BEEN *a United Airlines passenger going through Chicago O'Hare International, you have, in all likelihood, seen the moving walkways, complete with the neon display hanging from the ceiling that connects United Airlines terminals B and C. It's a fun—albeit more difficult, post-9/11—place to shoot, definitely worth being hassled by the TSA. While passing through with my family, I, once again, called upon my Leica D-LUX 3 and my daughter Sophie. With the camera set to Aperture Priority mode, f/5.6, and ISO 100, and with the rear curtain sync activated, I simply placed the camera on the handrail, which meant it would be moving during this 1/2 sec. exposure. As the exposure began, the neon lights overhead were recorded as blurs, and with the flash firing at the end of the exposure, Sophie was now illuminated.*

Leica D-LUX 3, ISO 100, 1/2 sec. at f/5.6

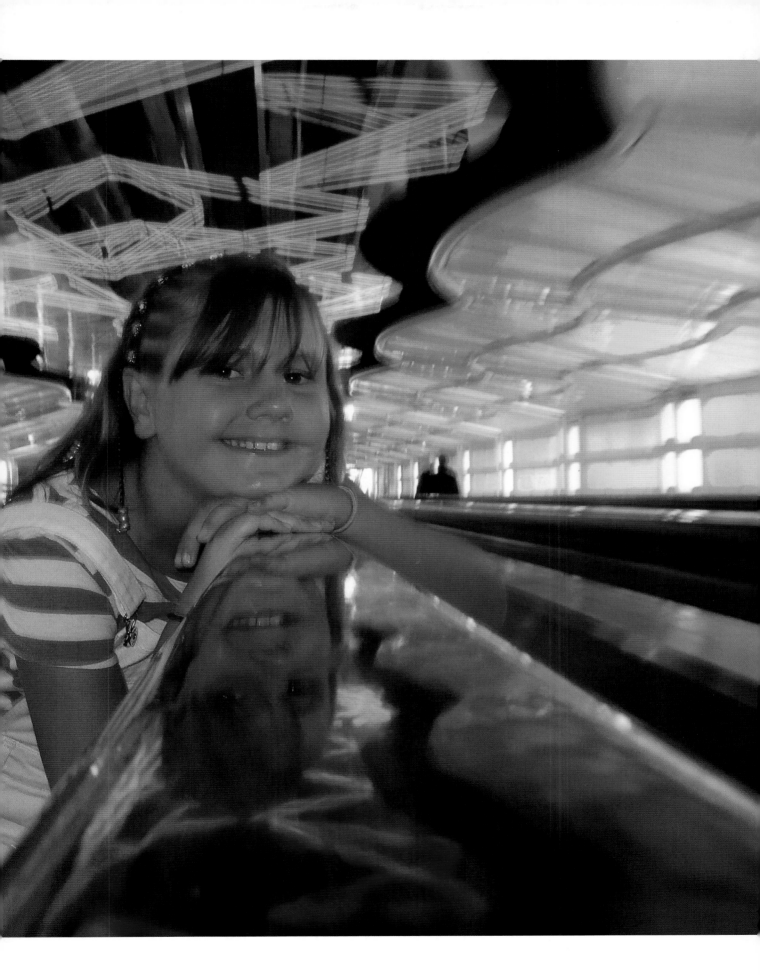

FILTERS

When it comes to moving subjects, you will soon discover the need or desire to "slow things down" to a shutter speed that is often just out of reach of recording a correct exposure. Even if you are using the lowest ISO possible in combination with the smallest lens opening, the slowest possible shutter speed still may not be slow enough for you!

I'm not a filter junkie, preferring, for the most part, the light that is available in all of its colorful splendor. However, there are three filters I take with me no matter where I go, and all three come in very handy when shooting motion-filled scenes.

POLARIZING FILTER

The first must-have filter is the polarizing filter, or polarizer. You can rotate it on the lens to remove the glare often seen in sidelit landscapes, and when used at a 90-degree angle to the sun, it will impart a much richer color to the landscape, including a deeper blue sky.

So, how does this help when shooting motion-filled scenes? Unless the landscape before you exhibits some movement (for example, a windy meadow of white daisies), it really offers no help at all. But, back to that windy meadow of flowers or that cascading waterfall or even that "simple" shot of pedestrians out on the rainy streets with their colorful umbrellas: When the polarizer is placed on the lens, it actually cuts the light levels down by about 2 stops—and that loss of 2 stops can sometimes make or break your motion-filled composition.

If you find yourself shooting a cascading waterfall, and you've already set the smallest possible aperture (f/22) and the lowest ISO (100), and you *still* find the correct exposure is a wee bit shy of your desired 1/2 sec. (your meter indicates 1/8 sec.), then you would immediately reach for the polarizer, since it will further reduce the exposure time by 2 stops and thus leave you with your desired exposure time of f/22 for 1/2 sec. The polarizer takes away 2 stops, so you have to get it back, and the only way to do that is to increase your exposure time by 2 stops.

"PEOPLE IN OREGON don't tan in the summer, they rust!" That was just one of the many highly successful advertising slogans used years ago to promote Oregon tourism. The point being, of course, that it does rain a lot in Oregon, but at least Oregonians have a sense of humor about it all.

I, for one, am not a fan of the rain, unless I'm planning to go to the woods for a day of shooting. One of my favorite haunts in all of Oregon continues to be Silver Falls State Park, where more than eight miles of hiking trails and eleven waterfalls provide countless shooting opportunities for the nature lover in most of us. Rainy days are my preference for the best two reasons of all: (1) I can be assured of recording some slow shutter speeds that will guarantee me that welcomed cotton candy effect in the falling water, and (2) I will get to use my polarizing filter (which not only reduces or eliminates that dull gray glare seen on all of the wet surfaces, but also reveals a far more colorful scene).

While shooting the Upper North Falls one autumn day, I was almost all set to photograph but had one final step to do: reach into my camera bag and place my polarizing filter on the lens. As you can see in the first example (top), there was a great deal of gray glare on the rocks and leaves that had fallen on the rocks, and why not? They were wet, thus highly reflective, and the sky overhead was indeed gray. Once the polarizer was in place, I simply rotated the outer ring while looking in the viewfinder to see the gradual reduction of all the gray glare in the scene (bottom). The difference is quite dramatic. Such is the power of the polarizing filter when shooting in the woods on any given rainy day.

And, if the reduction in glare is not reason enough to own and use a polarizer, then consider this added plus: A polarizing filter reduces the level of the light coming through the lens by 2 stops. If I'm at f/16 and I record an exposure of 1/4 sec., with a polarizer, I can shoot at f/16 for 1 second (1/4 sec. to 1/2 sec. is 1 stop, and 1/2 sec. to 1 second is 2 stops). A waterfall at 1 second is even more fluid, more angelic, more cotton-candy-like at this slower shutter speed, so make it a point to shoot your waterfall shots on rainy days and, of course, to use your polarizer.

Opposite, top: 17–35mm lens, tripod; opposite, bottom: 17–35mm lens, polarizing filter, tripod

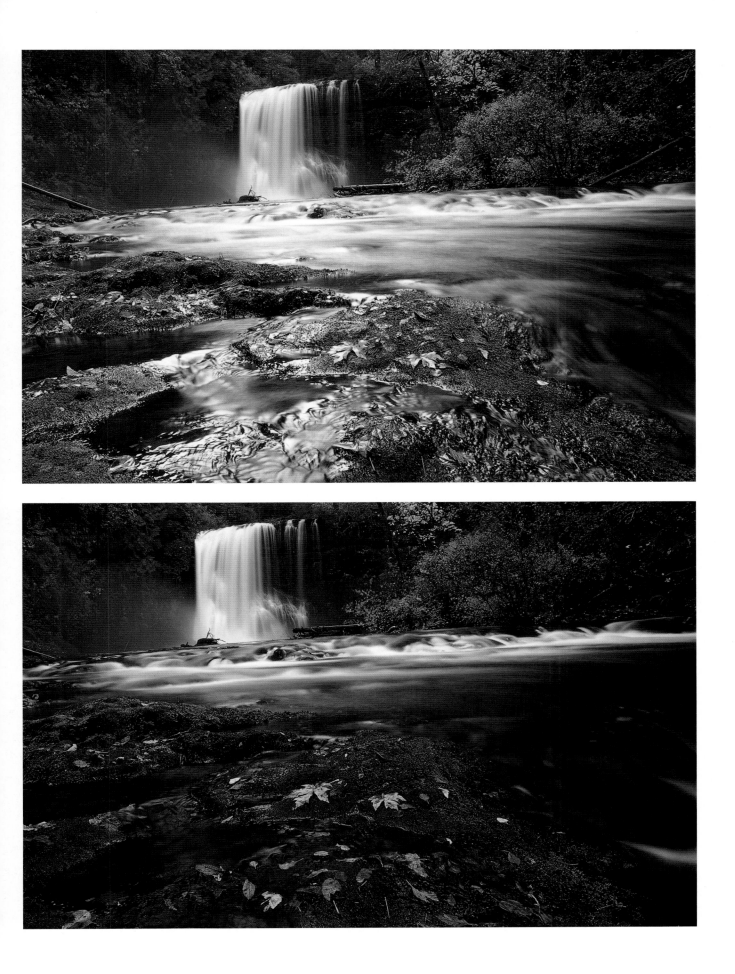

4-STOP NEUTRAL-DENSITY FILTER

The second filter I can't go anywhere without is my 4-stop neutral-density (ND) filter. Unlike the polarizer, this filter does nothing in terms of enriching my landscape or making the sky a deeper blue. It is, as its name implies, *neutral* in that it doesn't change the colors of my images at all. What it does do, however, is cut the light down by 4 stops, and 4 stops is actually quite a lot when you're talking about motion. It's a filter you may find yourself using when shooting ocean waves that you wish to make calm, flower landscapes that you want to use to indicate just how windy it was out there on the prairie, or city scenes that show traffic flow but you don't want to wait until dusk.

Again, if you find yourself at the smallest aperture number and the lowest ISO (100), but you're still finding that your shutter speed is not slow enough, you can place this 4-stop ND filter on your lens—and, just like that, go from an exposure of *f*/22 for 1/4 sec. all the way down to *f*/22 for 4 seconds.

ALONG THE CALIFORNIA COAST, *just north of San Francisco, you can find a number of rocky shorelines stretching for miles. A few miles north of Bodgea Bay, I came upon one such spot and spent the better part of an afternoon and evening there with a small group of workshop students. As the sun approached the horizon, the light became much warmer, and as you can see in the top image, I chose to shoot at a "fast" shutter speed of 1/30 sec. at f/16. The waves are certainly not tack sharp. A few minutes later, I added the 4-stop ND filter, which allowed me to record a much longer exposure. And by also stopping down to f/22, I was able to reduce the light entering the camera by 5 stops for an exposure of 1 second at f/22 (bottom).*

Opposite, top: Nikkor 70–200mm lens, tripod, ISO 100, 1/30 sec. at f/16; opposite, bottom: Nikkor 70–200mm lens, 4-stop ND filter, tripod, ISO 100, 1 second at f/22

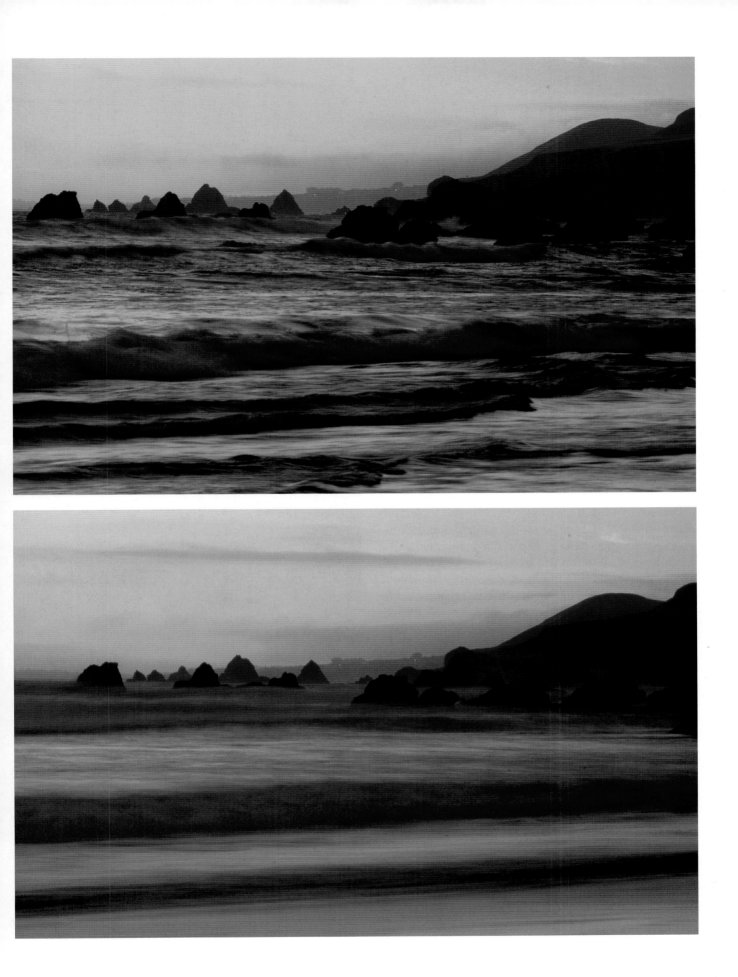

GRADUATED NEUTRAL-DENSITY FILTER

The third filter I always carry with me is much like the neutral-density filter, except it is called the graduated neutral-density (ND) filter. About twenty years ago, someone had the brilliant idea to make a filter that, when placed in front of the lens, would "reduce" the exposure of just the sky by several stops, thus making the brighter sky much closer to the same exposure required for the landscape below. And sometimes—not always, but sometimes—you may, indeed, find it necessary to use a graduated ND filter to facilitate a correct motion exposure of the overall landscape, sky included. Sometimes, when I set up a motion-filled exposure, I find that the sky ends up being a bit over-exposed since most of my motion-filled subjects are in the landscape below. But by placing my 3-stop graduated ND filter on the front of my lens (I use the LEE system of drop-in filters, by the way), I am able to "hold" the sky exposure back without it being overexposed, while at the same time maintain my correct exposure for the motion-filled subjects in the land-scape below.

Graduated neutral-density filters are clear, except for about the top third of the filter, where one finds the graduated effect applied. They're also a time-saver! Despite Photoshop's promise of being able to correct this kind of exposure problem, I still subscribe to the belief that if I can do it in camera, I will, since it will save me time!

WITH MY CAMERA ON A TRIPOD, I chose a low viewpoint to capture the motion of the incoming waves and the texture on the rocks while shooting shortly after sunrise at Portland Head Light in Maine a few years ago. Since I wanted to emphasize the motion of the waves, I chose to set the aperture to f/22 (again, the smallest aperture forces the slowest shutter speed), and since I made this image back in my film days, I was using a slow-speed film, Fuji Velvia ISO 50. I first pointed the camera to the early-morning sidelit rocks and adjusted my shutter speed until 1/4 sec. indicated a correct exposure. (Remember: "White" can create problems for the meter, which is why I didn't take a reading from the white foaming surf.) I then took a meter reading off the bluish sky above the lighthouse, and my meter indicated an exposure of f/22 for 1/30 sec. That meant that if I were to photograph this scene at 1/4 sec., the sky would be rendered as a 3-stop overexposure, which I didn't want.

Furthermore, I wanted to record a motion-filled exposure of the incoming waves at this slower shutter speed of 1/4 sec., which is the same shutter speed used to get that cotton candy effect in waterfalls. Due to the speed of the incoming surf and my closeness to it, I was assured of getting cotton candy surf at 1/4 sec., but I still had the problem of a sky that would be 3 stops overexposed—unless I added a 3-stop graduated ND filter to the lens. The image opposite was made at f/22 without the graduated 3-stop filter in place; it's a nice exposure of the rocks and surf, but the sky is much too overexposed. After I placed the 3-stop graduated ND filter in front of the lens (right), positioning it so that the graduated effect was covering only the blue sky, the exposure showed much better balance from the sky to the ocean below.

Opposite: 17–35mm lens, tripod, ISO 50, 1/4 sec. at f/22; right: 17–35mm lens, 3-stop graduated ND filter, tripod, ISO 50, 1/4 sec. at f/22

UNLIKE PHOTOGRAPHING PREDICTABLE moving subjects, shooting an actual lightning storm is anything but predictable! As far as I'm concerned, any shot of lightning is commendable, as it takes not only patience but a truly healthy dose of Lady Luck. Every spring, without fail, some of the best lightning storms seem to sit right over the top of Lyon, and in our current apartment, I have a front-row seat from our small terrace that faces Old Lyon.

Last year, try as I might, I failed miserably in my three attempts at shooting some of these storms. I was either too late on the trigger or was changing my flash card.

However, this year I was more determined than ever, and I was not at all disappointed. On one particular evening, over the course of thirty minutes the hilltop of Old Lyon took more than forty lightning strikes, and during several of my 4-second exposures, I was able to record multiple strikes, one of which you see here.

When shooting lightning, experience has taught me that f/8 is the aperture size needed for most strikes. For this shot, I was able to record an exposure time of 4 seconds at f/8 when I metered off the dusky blue sky. The advantage of shooting lightning storms at or shortly after dusk is that you do get to use longer exposure times, giving yourself a better chance of recording the strike than, for example, if you were shooting at a brighter time of day when your shutter speed might be only as slow as 1/2 sec.

Note that it isn't that the lightning needs the 4 seconds in this exposure, by the way. (Lightning bolts travel from cloud to ground at speeds up to 93,000 miles per second, and the actual flash of lightning lasts for about 1/1000 sec.) My reasoning for settling on my 4-second exposure is this: (1) This gets me the correct exposure for the city before me, and (2) while the shutter is open for 4 seconds, it is my hope that one or two lightning bolts will strike somewhere else in the overall composition. You might be thinking, Why not stop down to f/16, which would increase the exposure time to 15 seconds and increase the odds of recording multiple strikes while the shutter is open? In doing so, you would be at f/16, which, oftentimes, is not a large enough lens opening for many lightning strikes to record a proper exposure. You could arguably use a 2-stop ND filter, which would let you record at f/8 for 15 seconds, thus increasing your odds of multiple stikes, and I am all for that and would have done that here—but darned if I could find my 2-stop ND filter on this particular evening. Otherwise, I would have certainly been at f/8 for 15 seconds.

12–24mm lens, tripod, ISO 100, 4 seconds at f/8

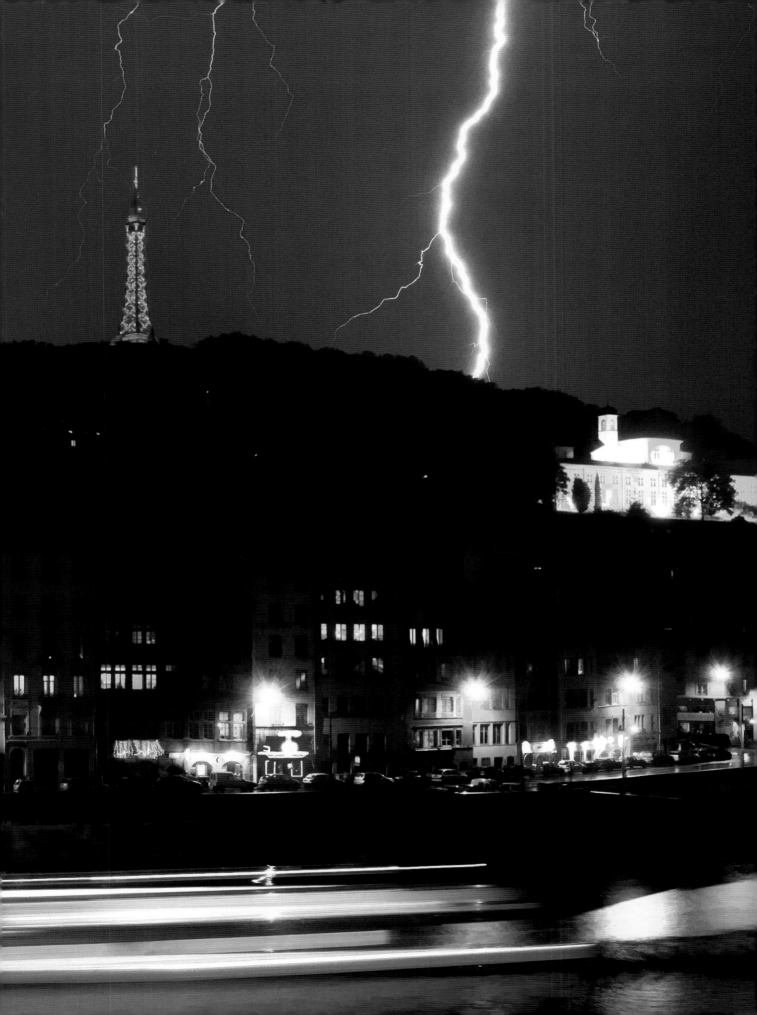

LIGHTNING SAFETY TIPS

Here are some safety tips for when you're working with lightning, compliments of the good folks at K-State Research and Extension (in Manhattan, Kansas).

■ Listen to the weather and heed weather warnings. The National Weather Service offers this rule: When lightning is seen, count the seconds until thunder is heard. If it is thirty seconds or less, seek shelter and stay there until thirty minutes after the last rumble of thunder is heard.

■ Seek shelter in a substantial building or enclosed metal vehicle. Avoid metal buildings or canopies, such as a picnic shelter, that may attract lightning.

■ If outdoors, avoid water, open fields, and high ground, as well as metal objects, such as power tools or farm machinery.

■ If lightning is striking nearby, crouch down. Place feet together and place hands over ears to minimize the sound from thunder.

■ If inside, unplug appliances. Minimize use of the telephone (which also can transmit an electrical charge), and wait to take a shower or bath until the storm has passed.

■ If you are trying to assist someone who has been struck by lightning, check to see if he or she is breathing, administer CPR, and ask someone to call 911. People who are struck by lightning do not carry an electrical charge. The charge that hits them can, however, damage or destroy their internal organs and cause death.

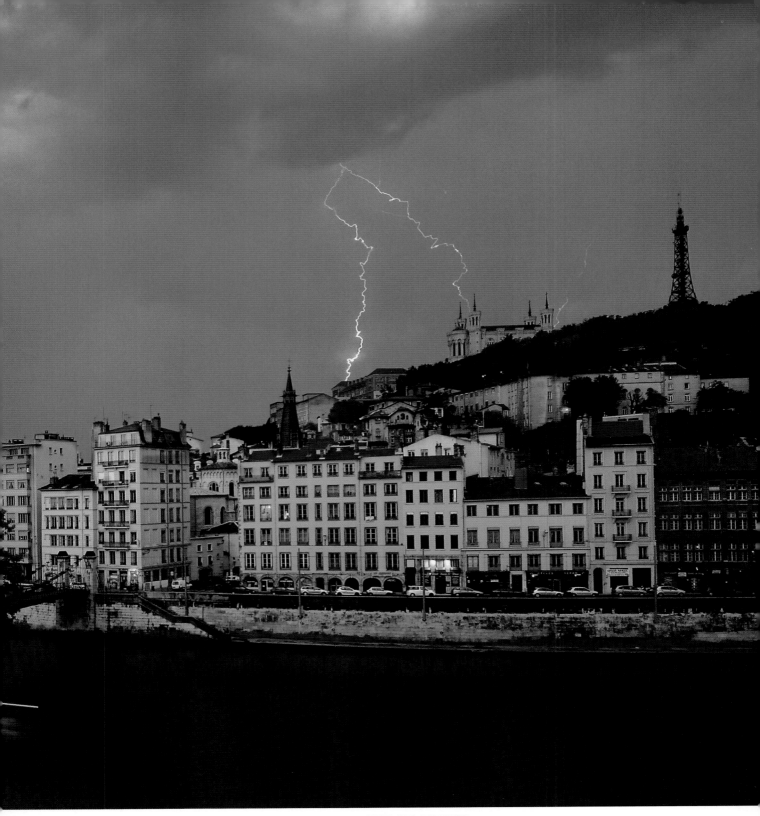

ONCE YOU DISCOVER *a good lightning spot, keep working it. I frequently return to this spot in Old Lyon, and if you compare this shot to the one on the previous spread, you can see the different results it's possible to get.*

12–24mm lens, tripod, 4-stop ND filter, polarizing filter, ISO 100, 8 seconds at f/8

RAW FORMAT: THE "ANTI" ND FILTER

Since a neutral-density filter reduces the amount of light coming through the lens, or extends the time the light is allowed to record an image on film or the sensor, is there such a thing as an "anti" neutral-density filter that will *increase* the amount of light coming through the lens, thus allowing for the use of faster shutter speeds and smaller lens openings? Yes, there is! But it's not called a *filter*, rather, it's called *underexposure*!

In all seriousness, this is a really cool "trick" that those of you shooting digitally can take full advantage of. Imagine that you find yourself shooting ISO 100 at your son's next soccer game and the light is anything but bright. In fact, it's so dark and dreary that the best you can get for anything resembling an action-stopping shutter speed is 1/125 sec. at *f*/4. If you were to shoot at this exposure, you'd run the risk of recording action-stopping images that are unsharp. Granted, you could have easily set the ISO to 400, 640, or 800, but that, of course, means noise, and you are all about razor-sharp images with the best color and contrast and with the least amount of noise.

So, what can you do? Choose the raw format. With raw, you can deliberately record images that are 2 stops underexposed and then "correct" these normally "bad exposures" in postprocessing. You can correct them so well, in fact, that no one will notice that they were ever too dark to begin with. And when would you deliberately shoot bad exposures that will be made good? The example of your son's soccer game is a good place to begin. If the fastest correct exposure you can come up with is *f*/4 for 1/125 sec., go ahead and shoot at 2 stops underexposed, which would be *f*/4 for 1/500 sec. You will record razor-sharp action-stopping images, albeit perhaps too darkly to really see on the monitor on the back of your camera. Then when you return home, load the image into the computer, and through the magic of postprocessing, you can bring these once too dark images into the light, so to speak. But again, you must be shooting in raw format, and you will need the likes of Photoshop Elements, Adobe Lightroom, Aperture, or a full version of Photoshop to process the underexposed files.

WHILE I WAS SHOOTING *a kayak competition in Prague with ISO 100, I wanted greater depth of field than the correct exposure of f/5.6 for 1/800 sec. would give me. For sure, I could have resorted to using ISO 400 or 800, but that would have meant recording more noise, and I didn't want that. So, what's the solution? A really simple one, in fact: With my aperture set to the depth of field I wanted—f/11—and with the same ISO (100), I simply kept shooting at 1/800 sec. The result was that every shot was 2 stops underexposed, but I knew full well that I could recover these stops when processing the raw images.*

The middle image opposite shows the underexposed picture in Photoshop. After adjusting the Exposure slider, I recovered the 2 stops I had lost and rendered a correct exposure—a correct exposure that would normally require the use of ISO 400 but that I was able to get without the grain/noise that ISO would have rendered here. Pretty cool, eh?

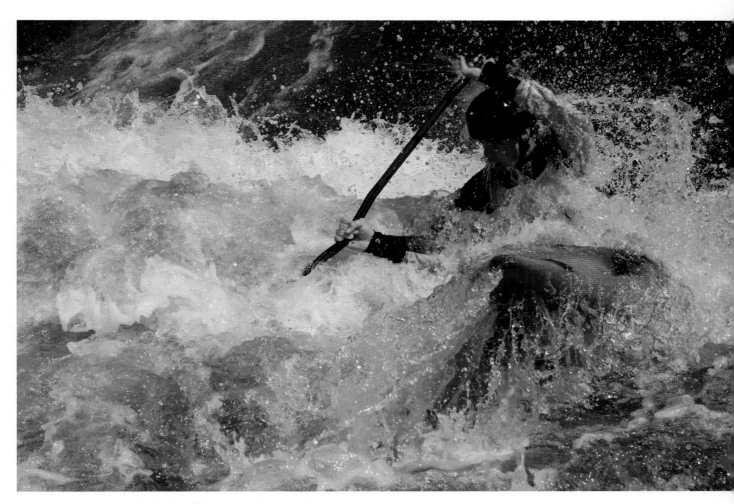

COMPOSITION

THE BASICS

There may come a day when setting a creatively correct exposure is all done by the camera, but I can't ever imagine a camera that tells you where to point it *and* what the best point of view should be *and* under what light conditions you should take the image. There are two constants in the art of image-making that no amount of technology will replace, and the good news is that both of these constants can be learned: learning how to "see" and learning the "art" of composition.

Photographic composition is based, in part, on order and structure. Every great image owes much of its success to the way it is composed, which is, in essence, the way the elements are arranged. Just as with any good story, song, or even potato salad, in photographic composition, several ingredients combine to create a compelling final result. And, there are many choices. You can make your primary subject appear small and distant against the drama of the light and weather unfolding in the landscape. Or, you can opt to fill the frame, edge to edge, top to bottom with only the faces in the crowd at a football game or that box of cherries for sale at the produce stand. You can compose to include a background that calls attention to the subject or that, alternatively, serves as a shocking contrast to the subject in front of it. You can change your point of view, shooting on your hands and knees or shooting down from a stairway above. You can compose the subject as a horizontal or a vertical and even at a diagonal.

In addition to these choices, you can utilize two specific characteristics that dominate every successful composition: tension and balance. Tension, which is the interaction among the picture's elements, affects viewers' emotions. Balance organizes these visual elements and keeps the viewer from tripping over the photograph's intent or meaning.

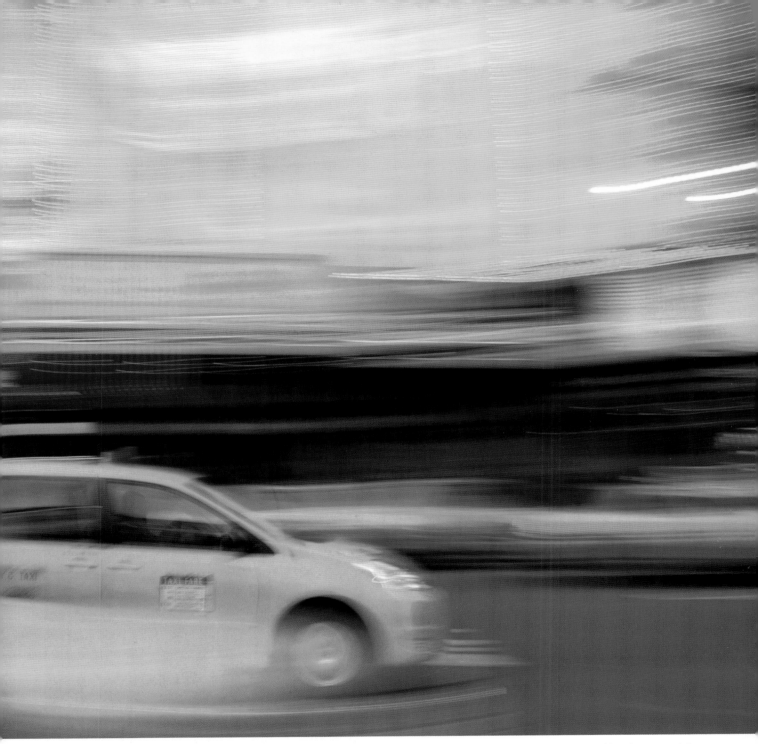

MOST OF US ARE FAMILIAR with white noise: The sound of the vacuum cleaner and the static from an untuned radio station are, perhaps, two of the more common examples. Most people, other than newborn babies, find white noise to be an irritant.

White noise also exists in photographic composition, but it is felt rather than heard. By that, I mean that the eye is constantly processing images throughout the day. It cannot focus on every detail to an equal extent, so it "edits out" the less important visual information. If you edit your imagery as a photography student, and you see a photo that's not sharp, that's white noise, too. When the eye sees something like this, a feeling of anxiety results. It is the eye's job, after all, to make sense of the images it is bombarded with, and when an entire image is not sharp,

the eye searches for "safer ground"—or, something the eye can bring into focus.

When I shot this image of taxis moving through Times Square in New York City, I knew, since I was panning, that I would be deliberately creating a great deal of visual white noise, but my intent was to leave at least one taxi sharp enough. The reason this image works is because the exaggerated level of visual white noise (the streaking) is coupled with a large enough area of relative sharpness (the taxi van) that the eye feels safe and is able to make sense of it all, despite the fact that the subject is really a chaotic, stressful, fast-paced environment.

17–55mm lens at 17mm, ISO 125, 1/30 sec. at f/10

FILLING THE FRAME

There is a lot of compositional theory out there being discussed in both photography and art classes and in Internet chat rooms all over the world, but unless you first learn to overcome the number one compositional problem, all the theory in the world isn't going to help you. And what *is* the number one problem? The failure to fill the frame. And man, if ever there was a subject that screams to fill the frame, it would be a motion-filled subject, for which freezing the action is the primary goal. Motion-filled images are, by their very nature, emotionally charged images. They are images with a "loud voice," and clearly, the more you fill up that frame with this loud voice, the louder and, thus, more attention-getting that image becomes. You do hope to create a buzz from your work, right? Then why not strive to turn that buzz into a roaring buzz saw! Fill the frame, especially when choosing to freeze the action of your subjects.

Perhaps you're not a fan of landscapes, but rather, you prefer the finer and often-hidden details of life. Or perhaps you simply love taking pictures of people. In either of these cases, as well, fill the frame. It's hard enough to concentrate on the action before you, let alone worry about your composition, so stop right there! I've used the following analogy in my other books, but it bears repeating here: Unless you requested otherwise, when you're in a restaurant, you expect the waiter to bring you that full cup of coffee you ordered. And should the waiter bring you a cup that's only half full, alarm bells will go off immediately. For good reason, you feel cheated and ask for that full cup you ordered.

Your reaction to the half-filled cup of coffee is understandable, and people may feel the same way when looking at your photographs. Unless you make it a point to fill the frame, like you would a coffee cup, your viewers will feel "cheated." All that empty space around your subject is no different than the empty part of the cup—something is missing. And, in the case of freezing action, that missing something is called *impact*! If you *don't* want your images to get people's attention, then do the following: Stand farther back from your subject, and don't use the longest focal length possible. If, on the other hand, you *do* want to create images that freeze action with impact, then do just the opposite.

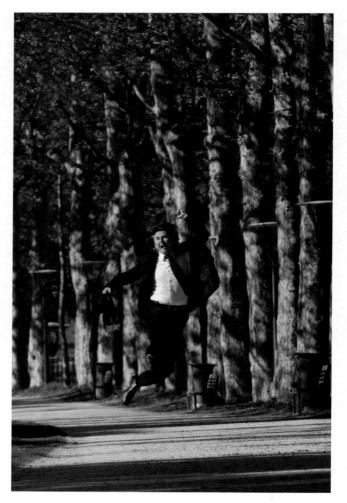

IS IT REALLY HARD to judge which of these two photos best conveys what might be a man jumping for joy over the news that he got the promotion or quit his job or just got divorced or just found out he is going to be a father or just won the lottery? Of course not! Clearly, the right-hand image has far more impact. The subject fills the frame, and as a result, it is much "louder."

With my camera on a tripod, I knew that since the action in this scene was coming toward me, I could shoot it at 1/250 sec. Choosing to shoot in Aperture Priority mode, I simply adjusted my aperture until 1/250 sec. indicated a correct exposure and told my model to start jumping on the count of three.

200–400mm lens, tripod, ISO 100, 1/250 sec.

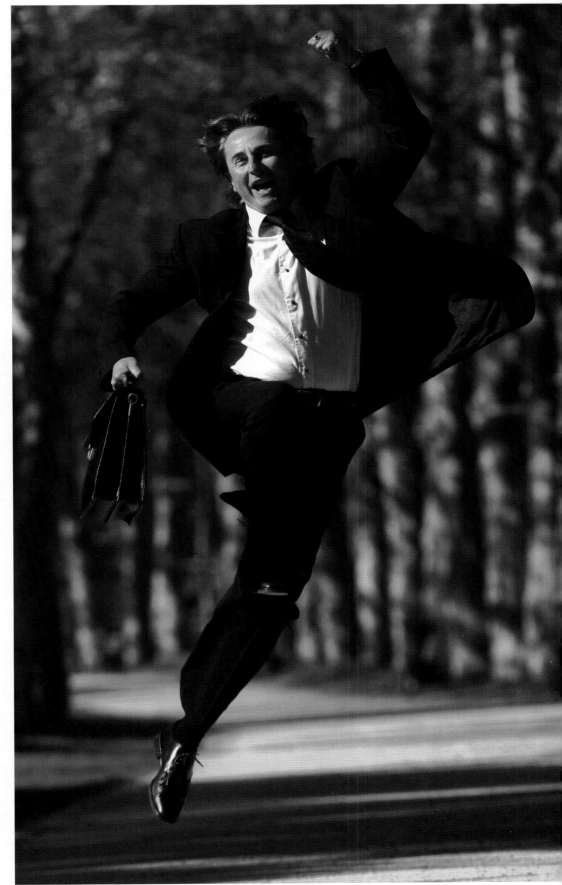

LEAVING ROOM FOR THE ACTION

There's a good "rule" to adhere to when composing motion-filled subjects inside a horizontal frame, and it applies both to images you make at blazingly fast shutter speeds and to those you shoot at much slower speeds. When action is on the move within your composition, it's a good idea to give that action "room to move" across the frame. Normally, this means composing the action within the first two-thirds of the frame. The direction from which the action enters the frame will determine if this is the left or right third.

ONE OF THE MORE FUN and challenging assignments I've done for one of my clients, Kodak, involved a half-day shoot at an equestrian event in northern California. I had never shot jumping horses before, so I was eager to give it a try. Within minutes, I had staked out one of the jumps, a five-foot, deep-red wooden fence. I felt that, from a low viewpoint, the lines would become a powerful statement of movement and speed, and knowing that horses would be soon jumping over them made the prospect of shooting from this location very exciting. It wasn't long before my excitement had turned to elation as the first horse made a beautiful jump, a jump that I was all set to record.

Handholding my camera, I chose to shoot in Aperture Priority at a shutter speed of 1/1000 sec. I simply adjusted my aperture until f/8 indicated a correct exposure at that speed. With my eye to the viewfinder, my finger on the trigger, and the camera set to Burst mode, I pressed the shutter release as soon as I saw the horse enter the frame from the left. Nine frames later, the horse was out of frame, and of the nine shots recorded, my favorite was the one below. In contrast, it's easy to understand why you might feel a bit cheated, a bit shortchanged by one of the later images, since the action is on its way out of the frame (opposite). It's as if it can't wait for you, as if you're trying to get on board a moving train that has already closed its doors and has begun to pull out of the station.

17–35mm lens at 17mm, ISO 200, 1/1000 sec. at f/8

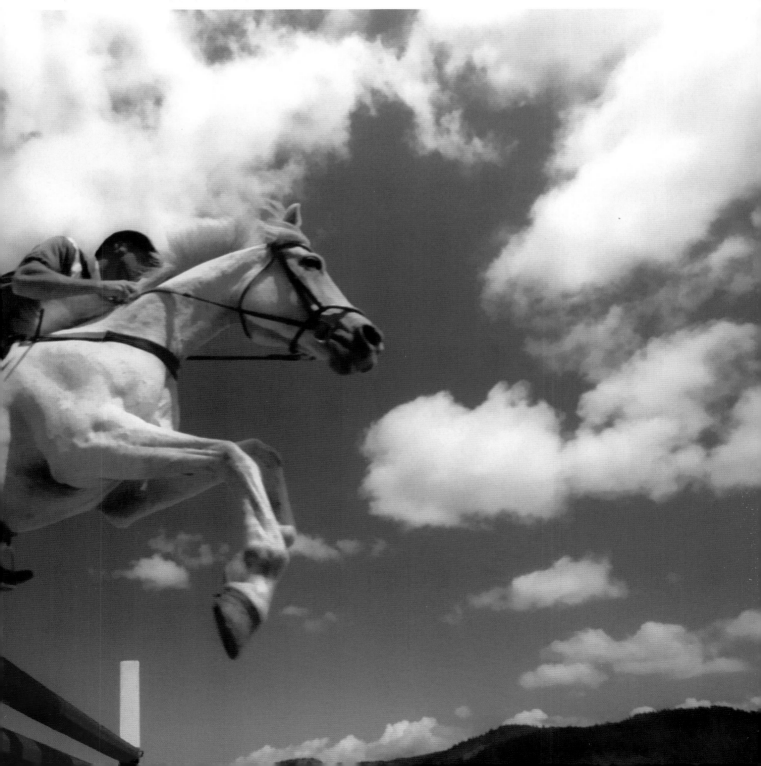

THE RULE OF THIRDS

In most sports, games are not allowed to end in a tie. Football, basketball, baseball, tennis, soccer, and golf must declare a winner, so overtime, extra innings, extra periods, and so on are played until one team or one player can finally be declared the winner. Why is this? It has everything to do with indecision and the tension indecision creates. Bottom line: Someone needs to be declared the winner before the brain can relax.

In photographic composition, the eye (and the brain) responds to images that are divided evenly in half in much the same way as it does to a tied game. The eye/brain can clearly see and feel the "indecision" in an image that is one half sky and one half landscape, for example, or what is called a 50/50 composition. The eye/brain feels this negative tension and is quick to respond with an unfavorable reaction. It demands that a "winner" (a "visual" winner) be declared.

The ancient Greeks were the first to become aware of this psychological phenomenon and soon developed a proven method of artistic composition to address it that is known as the Greek Mean. In its simplest form, the Greek Mean—also known as the Rule of Thirds—suggests that the compositional frame be divided into thirds, both horizontally and vertically, to aid in subject placement. In landscape compositions, this often means that there's a deliberate placement of the horizon line near the top or bottom third. As a general rule, if interest is greatest above the horizon line, then the composition should find the horizon line near the bottom third of the image, and if interest is greatest below the horizon line, the composition should find the horizon line near the top third. In effect, the visual weight of either composition makes it obvious that there is a "winner" between the sky above and the landscape below.

WHILE IN SAN FRANCISCO, *I stumbled upon CHEER, a San Francisco–based organization of present and former cheerleaders, dancers, and gymnasts who come together and perform at various events around the world in front of stunned audiences. They were practicing many of their routines and stunts in preparation for performing in the San Francisco Gay Parade later that day.*

Lying down low to the ground allowed me to showcase these high-flying cheerleaders against the early-morning blue sky. Had I shot the performers at eye level, I would have run the risk of "losing" them as they merged into one another. The composition here is also a classic use of the Rule of Thirds. The decision of where to place the horizon was an easy one: Since interest was greatest above the horizon, I placed the horizon near the bottom third of the frame. Handholding my camera, I chose an aperture of f/8 and adjusted my shutter speed until 1/500 sec. indicated a correct exposure. I was also shooting in Burst mode, which all but guaranteed a number of "peak action" compositions.

The image below shows a "Rule of Thirds grid" placed atop the photo so that you can better see just how important horizon placement is and also how important it is to take advantage of the "sweet spots" (the places where the grid lines intersect). Placing points of interest at or near these intersection points is key.

12–24mm lens, ISO 100, 1/500 sec. at f/8

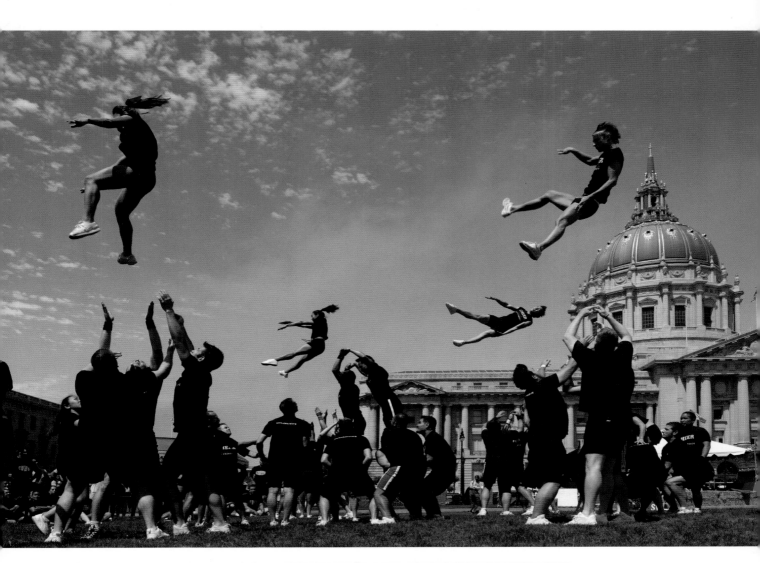

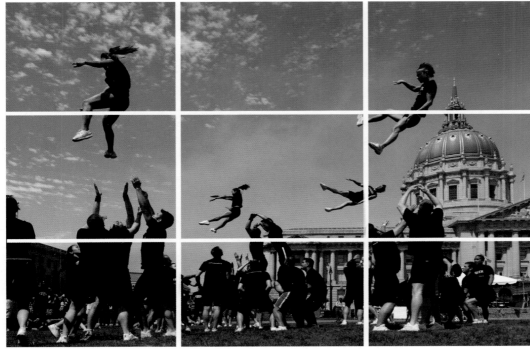

WORKING ON A DIAGONAL

The letter K had always been a favorite with George Eastman. He said, "The letter K seems to be such a strong and incisive sort of letter." The word Kodak, a name we all know, was derived by trying out a number of combinations of letters that made a word that started and ended with the letter K.

The reason I mention this is that the letter K also relies on the use of two diagonal lines: one that moves up and one that moves down. When compared to the letters B, C, or D, it should come as no surprise that, just like Eastman said, the letter K *is* a strong and incisive letter. By their very shape—curvilinear rather than angular—the letters B, C, and D offer up a different emotional reaction, something akin to a lackadaisical, laid-back kind of feeling. The letter K is far more active. It's a letter that's constantly on the move thanks to the two diagonal lines. It's fair to say that any diagonal line is far more active than any curvilinear line at least in one respect: A diagonal line is taking you somewhere, like it or not.

This whole idea of deliberately tilting the camera at a diagonal while shooting first appeared on the pages of fashion magazines. Slowly, it migrated to landscape photography, where it has also proven to be effective in some compositions. But, nowhere is deliberately tilting the camera on a diagonal more effective than when shooting action scenes. Any action scene is already active and made even more so when shot on the diagonal. As you look at the kayak images shown on pages 156–157, it's very clear that the image shot deliberately on a diagonal finds the kayakers moving at a much faster, and perhaps even too dangerous, speed.

Of course, it's an illusion created by simply tilting the camera, but the next time you're out and about shooting a sporting event, try a few shots on the diagonal, and don't be surprised if it becomes another useful tool at your disposal in your ever-increasing arsenal of ways to create some truly moving action scenes.

ONE OF THE SUGGESTIONS *I often make to my students is to "work your subject," and the day I photographed CHEER (on the previous page) was no exception. Finding another "picture in the picture" is a great habit to get into. By switching from my 12–24mm lens to my 70–200mm, I was able to isolate a single cheerleader from the large group.*

Again, I used the Rule of Thirds, placing the cheerleader close to the upper right grid intersection point (or sweet spot) and the dome primarily on the lower left one. This image also illustrates something else: the use of diagonals. Note how both the jumper and the dome are placed diagonally to each other. Handholding my camera, I set the aperture to f/8 and adjusted the shutter speed until 1/500 sec. indicated a correct exposure (no surprise there, since this was the same exposure I had used the moment before when shooting the image on page 153 with the 12–24mm). As the cheerleader came into view, I simply fired the shutter release—in Burst mode, of course.

70–200mm lens, ISO 100, 1/500 sec. at f/8

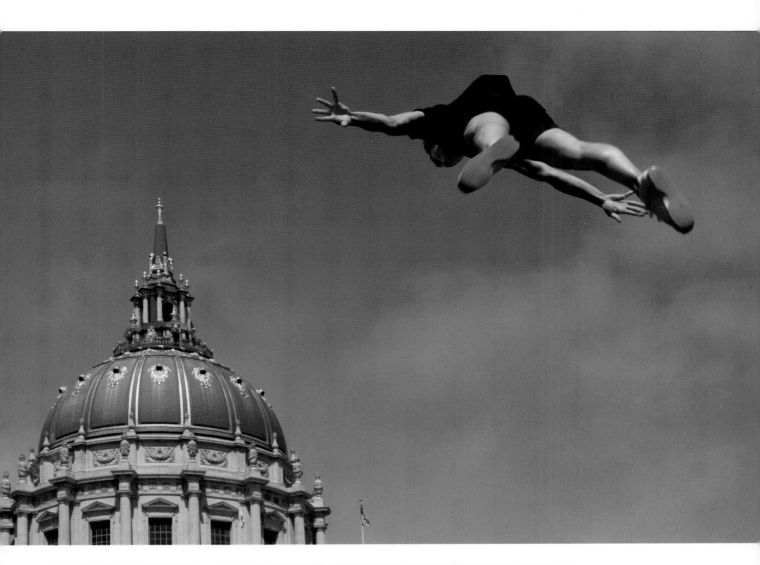

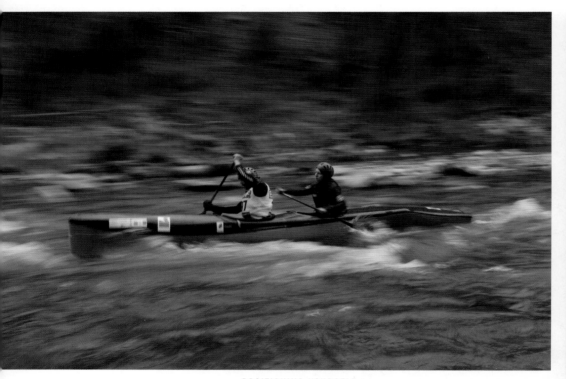

POSITIONING YOURSELF *(or turning your camera slightly) so that you create or emphasize diagonal motion can add energy to your images.*

Above: 17–55mm lens at 35mm, ISO 100, 1/15 sec. at f/13; right: 17–55mm lens at 40mm, ISO 100, 1/15 sec. at f/13

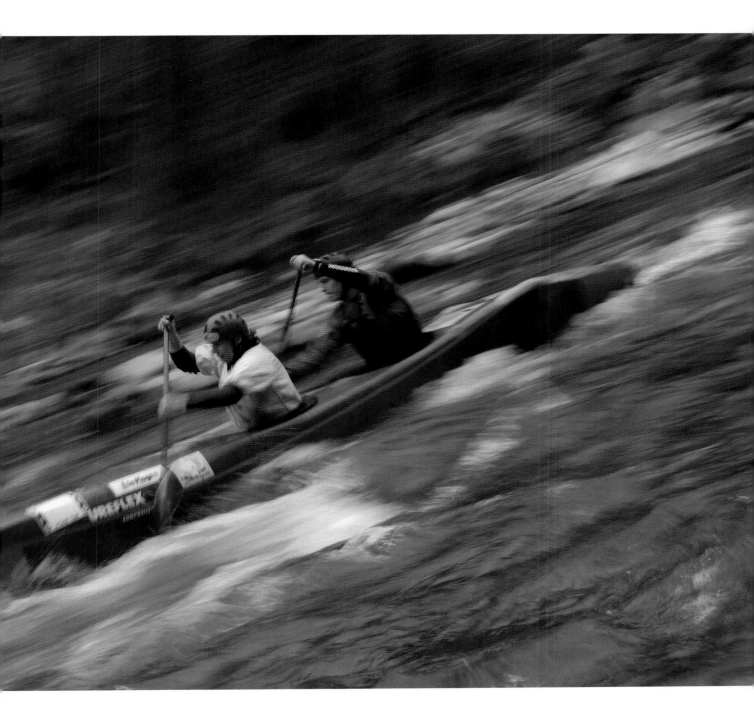

EXPLORING A THEME

Photographing motion-filled scenes can, no doubt, be a lifelong pursuit. Perhaps you will achieve your goal of becoming a well-known sports photographer or you will simply become more creative in your passionate pursuit of recording what you see. Whatever you do with your photography, exploring a subject theme over an extended period of time can be a good learning tool. It can help you determine both your compositional strengths and your weaknesses.

Knowing this, it was several years ago when I came upon "the red ball" at an Old Navy store in Greenwich Village in New York City. I bought two of them, in fact, intent on shooting the red ball in a variety of locations around the world doing what any ball would do: bouncing along on its merry way. Every one of my red ball images (more than two hundred strong to date) shows the ball in some kind of motion, and reinterpreting this subject will, I am sure, remain a lifelong pursuit for me.

Nikon D2X, 12–24mm lens, ISO 100, Fluorescent WB, 1 second at f/11

Nikon D2X, 12–24mm lens, ISO 100, Cloudy WB, 1/250 sec. at f/11

Nikon D2X, 70–200mm lens, ISO 100, Cloudy WB, 1/500 sec. at f/5.6

INDEX